IMAGES
of America

CHESTERFIELD
COUNTY

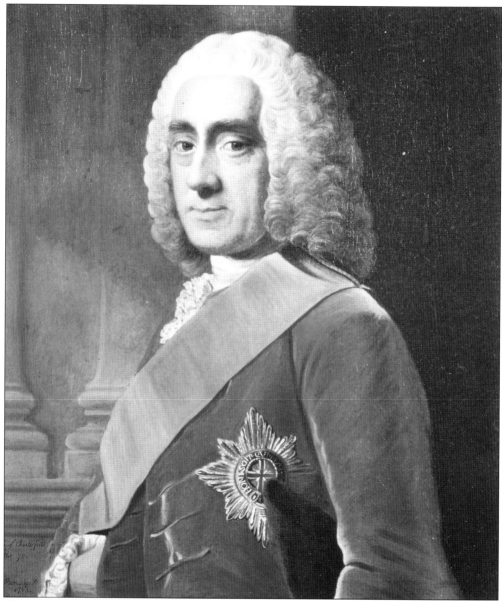

Chesterfield County was established in 1749. It acquired its name from Philip Dormer Stanhope, the fourth earl of Chesterfield. Born and raised in London, he became famous because of his manner and etiquette. He was also a prolific writer, and his writings showed details of the way things were in his day. As he was a prominent statesman in England, the legislators were probably hoping to show favor by naming the county after him. He never saw his namesake land before he died at the age of 79 in London. (Courtesy Chesterfield Historical Society of Virginia.)

ON THE COVER: Spring in the late 19th century brought out friends and relatives to spend time at various locations around Chesterfield County. Many spent the afternoon talking and enjoying the wonderful weather that brought so many people from the city of Richmond. Here a group of young people enjoy the afternoon at Camack's Mill. The mill, owned by W. J. Camack, was located near the Bellona Arsenal. (Courtesy Bon Air Public Library.)

IMAGES
of America

CHESTERFIELD
COUNTY

Frances Watson Clark

ARCADIA
PUBLISHING

Published by Arcadia Publishing
Charleston SC, Chicago IL, Portsmouth NH, San Francisco CA

Printed in the United States of America

Library of Congress Catalog Card Number: 2006922321

For all general information contact Arcadia Publishing at:
Telephone 843-853-2070
Fax 843-853-0044
E-mail sales@arcadiapublishing.com
For customer service and orders:
Toll-Free 1-888-313-2665

Visit us on the Internet at www.arcadiapublishing.com

This book is dedicated to Daniel H. Weiskotten, in memory of his tireless effort to research and preserve our past. His devotion to history inspired all who knew him. His work still benefits those who seek a glimpse into the past. He was a true historian.

CONTENTS

Acknowledgments 6

Introduction 7

1. Business, Government, and Communities 9

2. Friends and Neighbors 35

3. A Military Presence 65

4. Agriculture, Mining, and Manufacturing 75

5. Education 85

6. Houses of Worship 97

7. Organizations 105

8. Sports, Entertainment, and Events 113

Bibliography 127

ACKNOWLEDGMENTS

I would like to thank the Chesterfield Historical Society of Virginia for giving me access to their photographs and facilities. I would also like to thank Angie Wilderman, president of the society, for her help in making this possible. Faye Crenshaw, a staff member of the society, was invaluable in pointing me in the right direction and helping in my search. I would also like to thank Holly Rush for her encouragement and Liess Van Der Linden-Brusse, a volunteer who works tirelessly to keep the photographs in order and the information for them accessible.

My mother, Marion Joyner Watson, introduced me to historical research and taught me that while the past never changes, it does open up new clues to where we came from and hopefully where we are going. She inspired me to continue in this pursuit.

Others I would like to recognize for their assistance include Chris Ruth of the Chesterfield County Public Affairs Office. Whenever I didn't know who to contact about a picture or information, she was always there with a name and a number. Deborah Lammers, Bon Air Library branch manager, helped me go through books and pictures showing the Bon Air of the early 20th century. She also endured the repeated visits while I learned to use my scanner. Sarah Bartenstein and Lynne McCarthy-Jones of WCVE, the public broadcasting station in the county, shared wonderful pictures of the early days of the station. Edith Wilson Hobbs assisted me in finding pictures from her family who still live in the county. Debra Bingham of the Public Affairs Office of the Defense Supply Center Richmond also assisted me by providing pictures of the early work at the center.

Bettie Woodson Weaver, a county educator and historian, was invaluable in sharing the history of her family and the stories of the county and for knowing everyone.

As I did my research for this book, everyone I came in contact with was most helpful in getting me what I needed. Holly Walker of John Tyler Community College found early pictures of the school that show how it began. Jennifer Procise of Swift Creek Mill Theatre was tireless in her efforts to find an early show that depicts the reason they have been successful for so many years entertaining the community. Jerry Rudd, whose family has lived in the area for many years, was kind enough to share his grandparents' pictures. Mary Chalkley, whose family has been involved in the county fair for many years, shared photographs and stories, and I am grateful for her assistance.

A special thanks to my editor, Kathryn Korfonta, for allowing me to run ideas by her and giving me direction in putting this book together.

I am grateful to Dale Paige Talley. She helped me convince myself to do this book, and as she is a wonderful writer and dear friend, I use her as my guide to be inspired. I also wish to acknowledge my cousin, Nancy Birdsong Joyner Stewart, whose quest for creative outlets makes me not feel alone.

Finally I would like to thank my husband, Chris, and our children, Katherine and Philip. They were patient and left me alone when I needed to do research and pushed me when I needed to stay on track. I value their love and support.

INTRODUCTION

Chesterfield County, Virginia, is a historically and economically rich area located in the central region of Virginia. It is bordered on two sides by the James and Appomattox Rivers. The rivers played a large part in the county's development by bringing Native Americans to fish, bringing settlers to live, and allowing wildlife to flourish.

Chesterfield County was established on May 25, 1749, to give residents of the area more accessibility to their local government. Before that, they had to travel a long distance to reach their courthouse as they were part of Henrico County. Before they were a county, however, the people came here for many reasons. Algonquian Indians were drawn to the rivers and land for food and shelter and settled near Swift Creek.

The colonists who had settled in Jamestown were looking for a better place to live and room to grow. Under the leadership of Sir Thomas Dale, a group of settlers came up the James River to settle on Farrar's Island, in the area now known as Bermuda Hundred. They set up homes and began farming the land. One colonist, John Rolfe, recognized the importance of tobacco as a money crop and began farming it. Rolfe would also help relations between the colonists and the American Indians when, several years later, he would marry Pocahontas and bring her there to live at his home. The community Dale and the others founded was called the Citie of Henricus.

Several firsts in the New World occurred at this time. The first university in the colonies was established near Bermuda Hundred. Also the first hospital, named Mount Malady, was built. The first iron furnace was located in Falling Creek. However, in 1622, the tranquil life that had sustained the settlers came to an abrupt end when the American Indians held an uprising that would be known as the infamous Massacre of 1622. Most of the settlers' houses were destroyed, and many lost their lives in the attacks.

While this was a major setback to the area's development, by 1640, more colonists came to the area for a new life. The fear of attacks did not deter them, as they were coming here to seek freedom. Some came for religious freedom, such as the Huguenots. They chose the area near Midlothian to build their homes. While Chesterfield was an agricultural community in the beginning, manufacturing and mining would become important parts of its growth. Other colonists came to the area for a new life, knowing it would be hard. However, they knew they could derive many of the benefits they would never have in Europe.

Chesterfield served as a training camp for the Revolutionary War. Gen. George Washington had a camp set up to recruit soldiers to fight with the existing troops. Volunteers came to a site near the courthouse to train and prepare to fight the British. Many of Chesterfield's own farmers, statesmen, and citizens came here to enlist. The county also was host to Gen. Charles Cornwallis, the British commander, when he set up headquarters here on his way to Yorktown, where he later surrendered.

Patrick Henry lived in Midlothian at Salisbury during part of his term as governor of Virginia. While he was there, Thomas Jefferson, who had relatives in the area, would visit. Thomas

Jefferson's father, Peter Jefferson, was born in Chesterfield. Both of Thomas Jefferson's daughters married men from Chesterfield.

The Civil War was a time when the county was asked to give up her sons again as well as supply badly needed arms to the Confederate army. Bullets and guns were made in the furnaces at Bellona Arsenal. Many of the homes were occupied by Southern as well as Northern troops as hospitals and headquarters. Drewry's Bluff served as a pivotal part of the Confederate victory over the Union gunboats that tried to come up the James River to Richmond in 1862. It also served as the location of the Confederate Naval Academy. The county was not only the site of many battles during the war, but four prominent Confederate generals were also born in Chesterfield—Young Moody, David Weisiger, Edward Johnson, and Henry Heth.

After the war, the county had to rebuild, just as they had done after the Revolutionary War. Towns had been destroyed, while houses and livelihoods were gone. The will of the residents was never broken, and they made the county more prosperous.

The county served in the late 19th and early 20th century as a vacation destination for Richmonders at Bon Air. Summer houses and hunting lodges were built to allow residents to get away from the heat of the city. A rail connection made it easy for visitors to come and go as they pleased. Some visitors decided to make their homes here. The train system also helped the areas of Midlothian and Winterpock develop mines by carrying coal to supply not only Virginia but other areas up and down the seaboard.

During World War I and World War II, the county would again call upon its people to sacrifice and send its sons and daughters to fight. The county also housed the McGuire General Hospital, which was owned by the U.S. Army. During World War II, the hospital served as a stopping point for wounded soldiers coming home.

World War I and World War II took a toll on the resources and residents, but they were able to do their part for the war effort and continue to grow. The county was finally at peace and companies flourished. More people moved into the county, building homes and starting businesses.

Chesterfield has attracted a number of companies over the years that have produced jobs and tax revenue to allow the county to offer more to its residents. There is a nationally ranked secondary school system and a wide variety of activities from fishing in many of the rivers and lakes of the area to attending performances, art shows, air shows, and car races.

Chesterfield thrives today as a productive, growing group of communities that have joined together. The districts that make up the county today are Midlothian, Clover Hill, Matoaca, Dale, and Bermuda. The residents have formed a county that is strong in leadership, schools, friends, and good neighbors.

One

BUSINESS, GOVERNMENT, AND COMMUNITIES

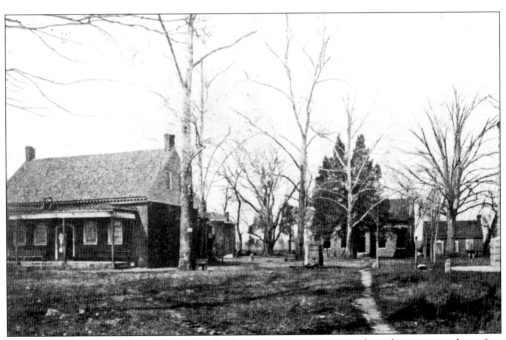

The first Chesterfield Courthouse was built in 1750 at a site central to the county where five roads intersect. John Booker was contracted to build the courthouse, the jail, and the pillory. The courthouse was built near the community called Cold Water Run. The courthouse served the county for 167 years before it was replaced. In 1781, the building sustained damage to the roof when a British general, William Phillips, came through Chesterfield. The courthouse was the scene of an early trial for religious freedom when seven Baptist ministers were held in the adjacent jail for "breach of ecclesiastical law." (Courtesy Chesterfield Historical Society of Virginia.)

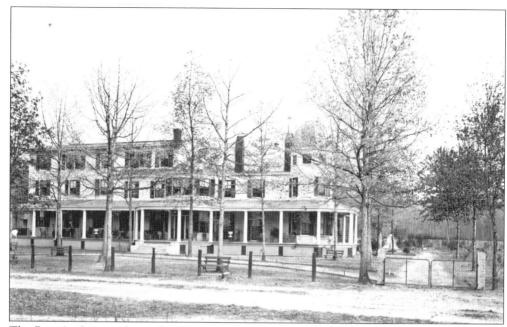

The Bon Air Inn was located at 2200 Burroughs Street in Bon Air. Built by A. F. Noel, it was turned into an inn in 1910 by Mrs. T. M. Kennerly. People staying at the inn could live there full time and go to downtown Richmond for work. In 1917, the inn was partially dismantled when the owners decided to close. (Courtesy Chesterfield Historical Society of Virginia.)

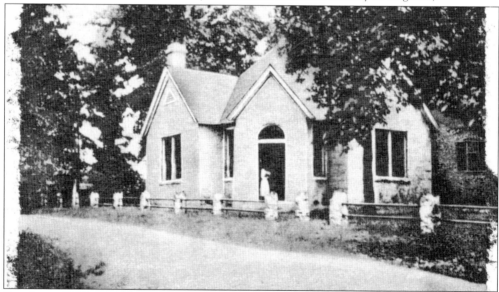

Rev. James K. Hazen, the minister of the Bon Air Presbyterian Church, served from 1885 until he passed away in 1902. As a leader of the community, it was felt he should be honored with a memorial befitting his love for literature. The Hazen Memorial Library, completed in 1903 near the Bon Air Hotel Annex, served the residents of Bon Air for many years. It was one of the first libraries in the state. Books were donated, and the library became a social center for the area. It was replaced in 1976 with a new Bon Air branch library located on Rattlesnake Road. (Courtesy Bon Air Public Library.)

The Bon Air Post Office was the center of social life in Bon Air. The women of the community would sometimes come twice a day to get their mail and catch up on the gossip. The building was constructed in 1916 on Rockaway Road. The train was used to transport the mail from the main post office in the city to Bon Air twice a day. Miss Julia Powers was named the first postmistress and held that position for 29 years. She had an unorthodox way of running the office. She decorated the outside with flowers and in the back of the building she even raised chickens, whose eggs she sold to the ladies coming to pick up their mail. The mail was transported from the railroad station by Dr. C. M. Hazen, who during his retirement found it entertaining to load the mail in a wheelbarrow and push it up the hill. In 1952, the post office was moved to a larger facility. (Courtesy Chesterfield Historical Society of Virginia.)

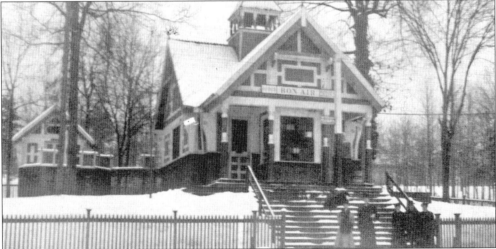

Bon Air was a very progressive community in the late 19th century. It was established as a summer resort community for, and later became the permanent residence of, some of the leaders of the county and their families. Tourists and residents enjoyed the cool evenings and fresh air they lacked in the city. The Richmond and Danville Railroad, which later became the Southern Railroad, was begun in 1849 and was a great contributor to the influx of people coming to the area. Brown's Summit was the original name of the area, but it was changed to Bon Air, meaning "good air." The Bon Air Railroad Station and water tower, built in 1880, had been moved from the site of the Great Cotton Exposition in Atlanta. (Courtesy Bon Air Public Library.)

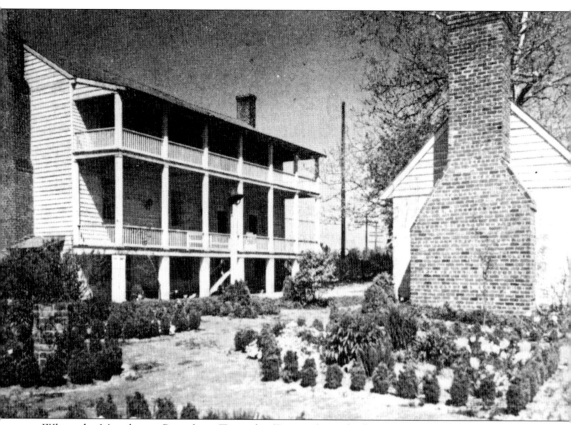

When the Manchester-Petersburg Turnpike (Route 1) was built, a number of taverns sprang up along the road to accommodate travelers. The Halfway House, on Route 1 near the intersection of present-day Route 1 and Route 288, was built around 1820 by Capt. William Hatcher. He ran a stage line along the road and used the building as a place to change the horses as well as a tavern. During the Civil War, the house was used as Gen. Benjamin F. Butler's headquarters as well as a hospital and medical supply depot for Civil War soldiers. Reportedly, some well-known visitors included Robert E. Lee and Charles Dickens. The house fell into disrepair, and in the 1930s, it was reported that tenants living there kept hogs in the basement. The house was saved by W. Brydon Tennant, a local attorney, who spent several years bringing the house back to its original state. He even rebuilt the kitchen behind the house in a log design. He allowed tours of the house once it was complete. When Tennant died, the house was purchased by the Benders. They remodeled to accommodate a restaurant and ran it until 1982, when it was purchased by the Youngs. It is still in use today. (Courtesy Chesterfield Historical Society of Virginia.)

Chesterfield benefited from the assistance of the state and federal governments to support a system of extension agents. Their mission was to offer continuing education to county residents. Robert F. Jones was one of those agents assigned the task of bringing the extension program to the black families of Chesterfield. He served in that capacity from 1921 until 1957. (Courtesy Chesterfield Historical Society of Virginia.)

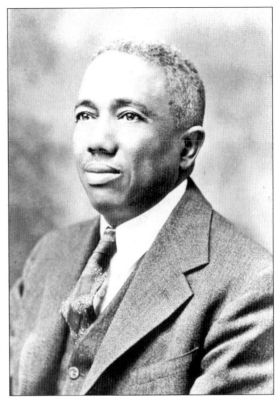

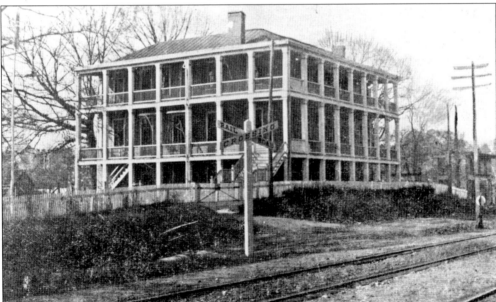

Tourists came to the popular summer resort at the Chester Hotel. Built in 1840, several cottages on the grounds served residents of Richmond and Petersburg. The hotel was conveniently located across the street from the Atlantic Coast Line Railway Station for travelers. There was a period in the late 19th century that the Chester Female Institute occupied the building. The hotel was torn down in 1938. (Courtesy Chesterfield Historical Society of Virginia.)

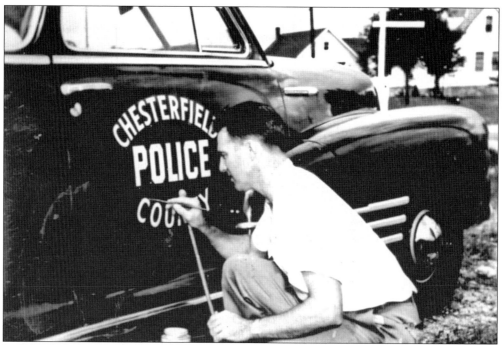

In 1949, the police department received their first police car. It was a 1949 Chevrolet, and others would follow. The car is shown here having the lettering painted on by Mr. Martin at his paint shop on Belt Boulevard. (Courtesy Chesterfield Historical Society of Virginia.)

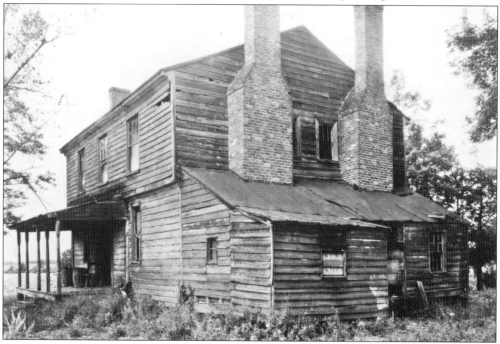

Frazier's Tavern was located on Midlothian Turnpike (Route 60) and served travelers going out to the western part of the state of Virginia. Many taverns in the area would allow patrons to sleep in rooms shared by other travelers. (Courtesy Chesterfield Historical Society of Virginia.)

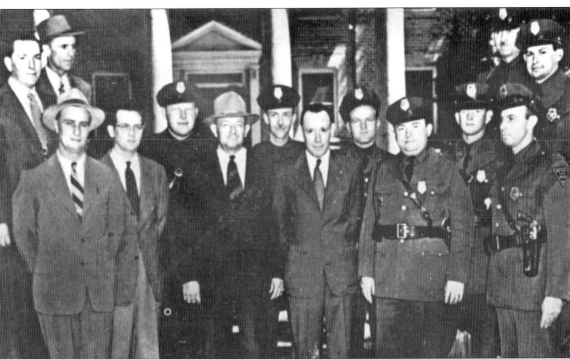

The police department in Chesterfield County is shown here in 1948. The officers were, from left to right, (first row) D. W. Murphey (detective), C. S. Romaine (chief radio dispatcher), W. E. Martin (patrolman), I. E. Bowman (detective), F. T. Smith (patrolman), C. W. Smith (chief of police), C. W. Cummingham (patrolman), E. P. Gill (patrolman), R. C. Phillips (patrolman), and R. E. Feeback (patrolman); (second row) B. C. Furman (radio dispatcher), R. W. Koch (detective), H. N. Terrell (patrolman), and W. B. Gill (patrolman). (Courtesy Chesterfield Historical Society of Virginia.)

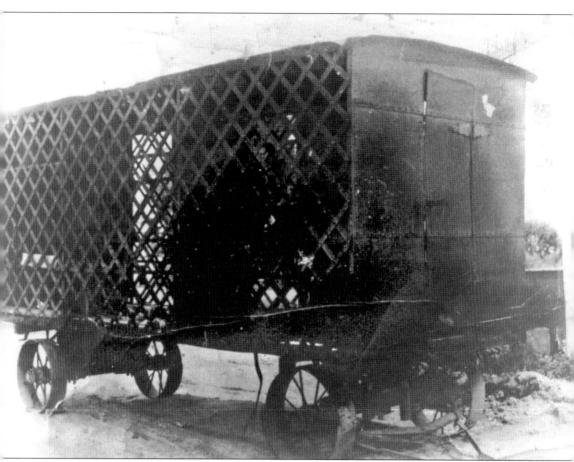

This prison wagon was a relic of the Civil War, and it is believed it might have been used to transport war soldiers from the prisons in Richmond. During the early 20th century, it was used by the county to transport prisoners in work details. The wagon was 18 feet long and 7 feet wide and had bunks for 12 prisoners. The county used the prisoners to maintain the gravel roads throughout the county. Eventually the wagon was stored at Colgin's on Hopewell Road in Enon. (Courtesy Chesterfield Historical Society of Virginia.)

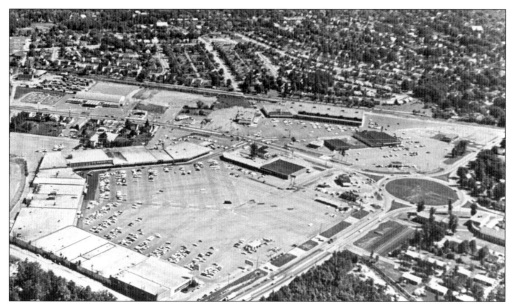

For many years, downtown Richmond was the center of shopping of the metropolitan area. Major department stores like Thalhimers and Miller and Rhoads brought county residents into the city to get the latest fashions and accessories. However, in 1958 at Belt Boulevard and Hull Street, a major shopping center was established. Southside Plaza, developed by Stanley Property, was ahead of its time in offering a wide variety of stores and services to residents of the county. Miller and Rhoads opened its first suburban store here. The center opened March 6, 1958, with 33 stores. For many years, Southside Plaza was the major shopping center of the area. However, in the early 1970s, when Cloverleaf Mall was built, the plaza was impacted by the competition. (Courtesy Chesterfield Historical Society of Virginia.)

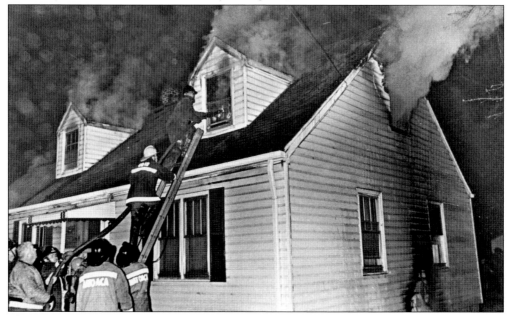

The Matoaca Fire Department is shown here putting out a blaze at a resident's home in the Ettrick area in the late 1950s. (Courtesy Chesterfield Historical Society of Virginia.)

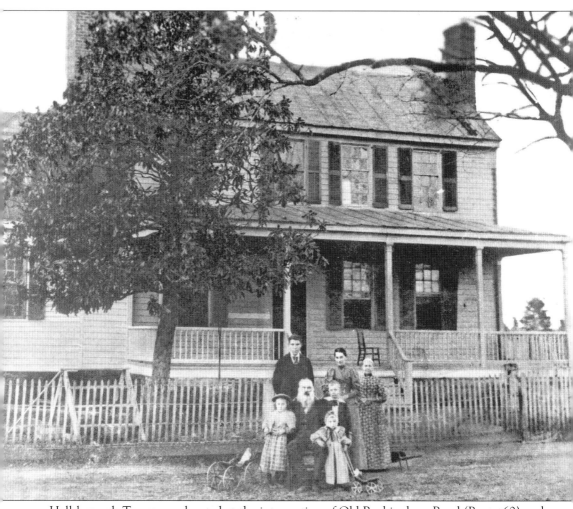

Hallsborough Tavern was located at the intersection of Old Buckingham Road (Route 60) and Huguenot Springs Road. It served as the social center for the community for most of the 19th century. James Howard acquired the house in 1810 and began running a tavern and store. In 1826, it was sold to Austin Spears, who continued to run the tavern and enlarged it in 1832 so that he could offer sleeping accommodations. There was a post office in the building from 1834 until 1849. When Spears passed away in 1845, his wife continued to run the tavern and store. The tavern was raided during the Civil War by Union soldiers who took everything but a mule and the family silver, which had been hidden in the stump of a tree. The Spears family continued to live in the house well into the early 1970s. The family in front of the tavern is, from left to right, Vassar Clark, William Spears (seated), Willie Spears Watkins, Virginia Watkins, Gladys Spears, unidentified, and Mrs. Miles, the housekeeper. (Courtesy Chesterfield Historical Society of Virginia.)

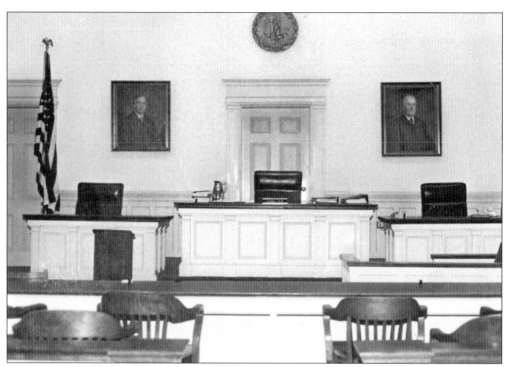

The 1917 courthouse interior, shown here, was remodeled in the late 1960s to modernize the facilities. (Courtesy Chesterfield Historical Society of Virginia.)

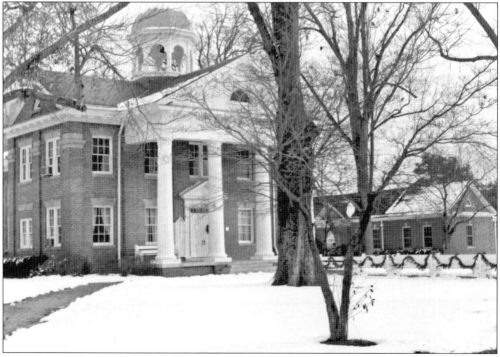

As the county grew, so did the need for a more modern facility to house the county offices and courts. Pictured here is the 1917 courthouse. (Courtesy Chesterfield Historical Society of Virginia.)

Harry Daniels has been a prominent figure in Chesterfield County politics for many years. Daniels, who worked at Philip Morris, was elected to represent the Dale District in 1979. He served for many years on the board of supervisors and held the office of chairman of the board several times. He was honored by having a park named for him next to the intersection of Ironbridge Road and Route 288. (Courtesy Chesterfield Historical Society of Virginia.)

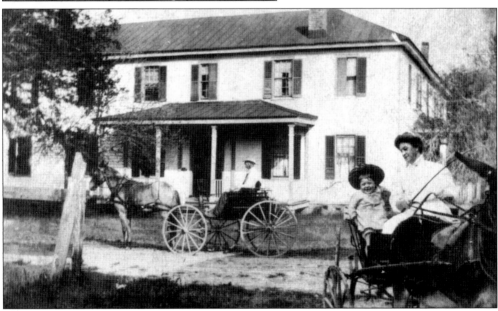

The hotel at Chesterfield was a 22-room building located at the corner of Ironbridge and Lori Roads. Built around 1850, it was owned by Mr. and Mrs. John Pierce. At one time, it was called Pierce's Hotel. They served meals along with offering rooms to rent. Their establishment was very popular in the summer with tourists, and some families lived there for long periods. The Philip V. Cogbill family lived there from 1897 until 1900 after their house burned down. They later moved into Magnolia Grange. The photograph shows Katherine Cogbill Cumming, daughter of Philip V. Cogbill, in the buggy. Next to her is seated Mrs. Watson, wife of Circuit Court Judge Watson. (Courtesy Chesterfield Historical Society of Virginia.)

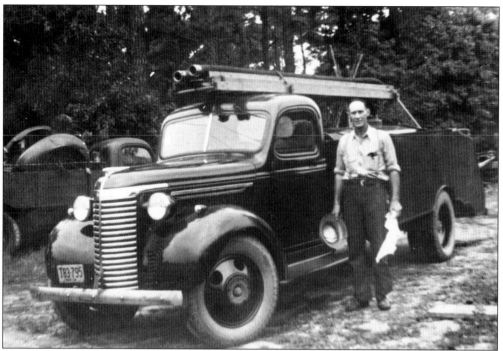

Albert Lee Smith was the Chesterfield County fire chief under the Virginia Division of Forestry. He is pictured here in 1944 next to his fire truck. The forestry division of that time was working on renewal of the forests and land. (Courtesy Chesterfield Historical Society of Virginia.)

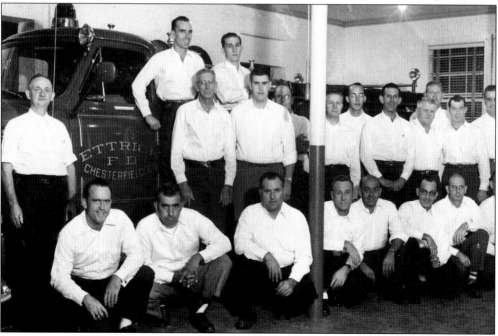

Ettrick Fire Department firefighters are pictured here in October 1956 at their station house. The volunteer organization was begun in 1928. It was the first in the county. (Courtesy Chesterfield Historical Society of Virginia.)

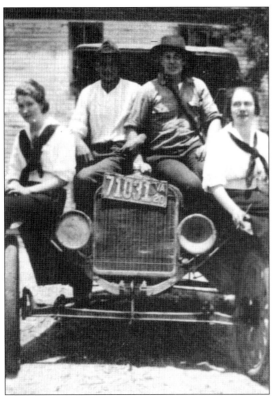

Ruffin and Graves was a general store serving the residents of Chester. Pictured here are some employees of the store on the delivery truck. (Courtesy Chesterfield Historical Society of Virginia.)

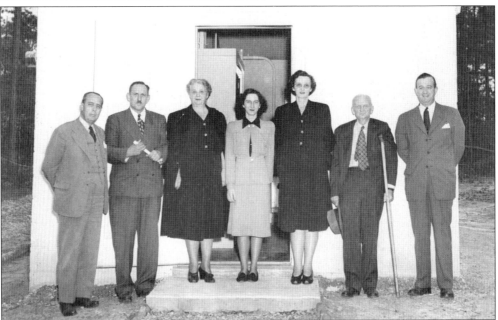

The Chesterfield County extension agent in 1947 was P. Rixey Jones. He retired in 1949. Standing in front of the building that housed the first telephone in Winterpock are, from left to right, unidentified, P. Rixey Jones, Ruth Chalkley, Ann Winckler Eudailey, Lindon Chalkley Winckler, Horace L. Chalkley, and unidentified. (Courtesy Chesterfield Historical Society of Virginia.)

Amelia Rumps Sinclair was the postmistress in the early 20th century for Centralia. Her husband, John Henry Sinclair, was postmaster. As was the case with many post offices, this one was attached to the train station. Once a transportation hub for the area, Centralia's importance declined, and in the 1950s, the station closed and the post office was moved to Chester. (Courtesy Chesterfield Historical Society of Virginia.)

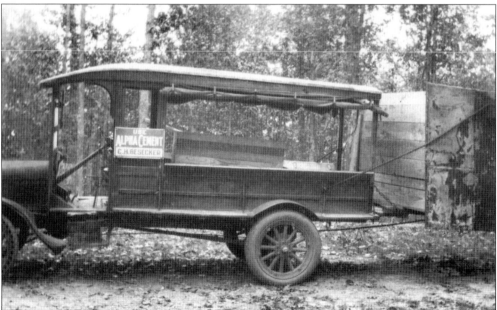

For many years, septic systems were outhouses, and companies sprang up that would deliver the facilities. One such company, owned by C. H. Besecker and shown here in the late 1920s, had a truck transporting an outhouse to a local home in the area. The sign is an advertisement for cement. It says "Use Alpha Cement C. H. Besecker." (Courtesy Chesterfield Historical Society of Virginia.)

The Bank of Chester was established in 1903. The building pictured here in 1915 was the old bank building located at the corner of Main Street and Richmond Road. During the Depression, banks were not always secure. After Franklin D. Roosevelt was elected president, he declared a "bank holiday" and closed all of the banks temporarily. Deposits were frozen. Ten days later, any bank that could prove to be solvent could reopen. While some other banks in the area failed, the Bank of Chester was one of the first to reopen. It later became the post office, and in 1982, it was a beauty parlor. (Courtesy Chesterfield Historical Society of Virginia.)

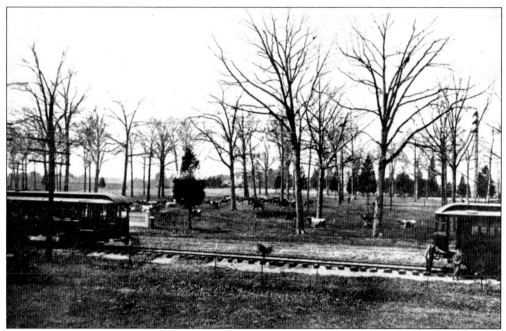

The Virginia Passenger and Power Company operated an electric trolley for freight and passengers between Petersburg and Richmond. It had several stops in Chesterfield as it passed through the county. The picture here shows the trolley as it passes through Bellwood Farms. The trolleys ran from 1902 to the 1940s with more than 20 stops. They left every 30 minutes and were very reliable. There were single-track sidings set up along the way to allow cars to pass. (Courtesy Chesterfield Historical Society of Virginia.)

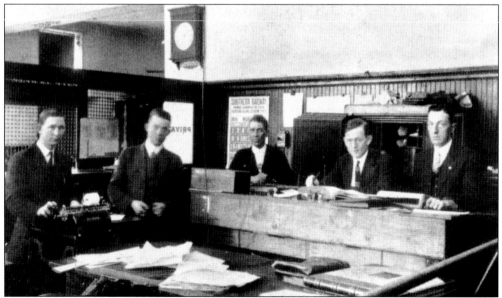

The Virginia Passenger and Power Company Trolley Office was located in Petersburg, at the end of the line. Pictured in the office in 1914 are, from left to right, superintendent Frank Pond, two unidentified men, G. C. Wilkinson, and unidentified. (Courtesy Chesterfield Historical Society of Virginia.)

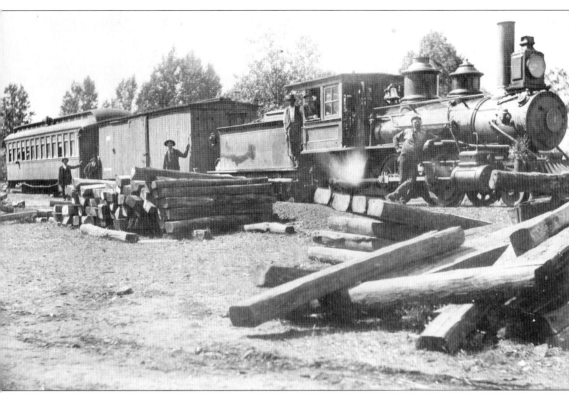

The Tidewater and Western Railroad at Chester supplied trains to travel between Farmville and Bermuda Hundred. Pictured in 1910 is one of the trains that carried coal from the mines and lumber, as well as other goods. The main offices of the line were located in Chester after being moved in 1905. The train also carried passengers. Some cars only held 16 passengers at a time. The company went bankrupt in 1917, and eventually the rails were pulled up and used in Europe by allies of the United States to repair their war-damaged tracks. (Courtesy Chesterfield Historical Society of Virginia.)

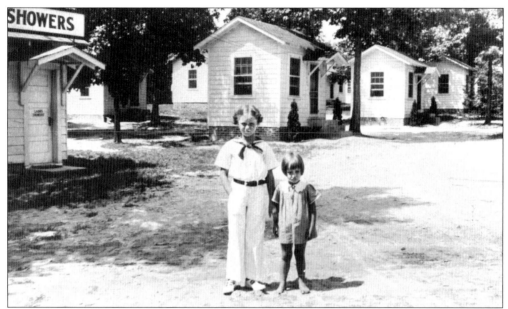

Route 1, the major road north to south on the East Coast, ran through Chesterfield County. To accommodate the many travelers and tourists that passed through the area, motels and tourist camps opened up. Parnell Tourist Camp, pictured here at Osborne Road and Route 1 North, was one of the many places people could stop. Adults and children played, ate, and slept. Shown here is Nancy Parnell (left) and a young tourist staying at the camp. The owner, C. J. Parnell, owned the Tourist Camp and Tavern as well as being a local pilot. He died in 1943 during an airplane accident at Langley Field while flying for the Civil Air Patrol. The Parnell Airport, built in the late 1940s south of East Belt Boulevard and Bells Road, was named in his honor. (Courtesy Chesterfield Historical Society of Virginia.)

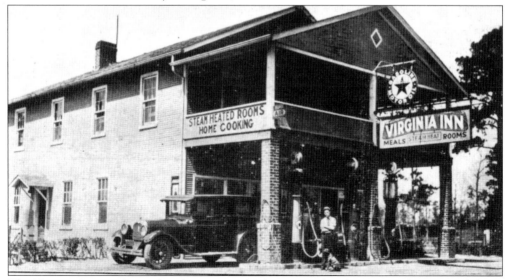

The Virginia Inn was located at the corner of Osborne Road and Route 1. This postcard shows the inn, which was owned by the Felter family, in the early 20th century. Travelers could stop and get steam-heated rooms and home cooking. The inn was torn down in 1960. (Courtesy Chesterfield Historical Society of Virginia.)

For several years, the county was growing faster than they facilities they had could support. A new courts building was required that would give space to the circuit court, county court, juvenile court, and the traffic court. This building was also planned to house the clerk's office. The building was completed in 1968. It is located on Route 10. (Courtesy Chesterfield Historical Society of Virginia.)

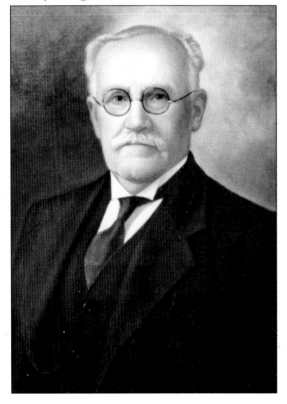

John Benjamin Watkins was a prominent businessman and statesman in Chesterfield County. He was elected to represent Chesterfield in the State Senate in 1908. He also held the position of president of the Chesterfield County Association, an organization he began. He served on the boards of Virginia Polytechnic Institute and Farmville State Teachers College, now Longwood University. As a businessman, J. B. Watkins began a nursery in the Midlothian area with his brother in 1876. They carried mail-order fruit trees. People from around the South used their trees after the Civil War to replenish the area. They added other trees, shrubs, and plants and became an importer of European plants that are used all over the United States today. The company flourished and has been family owned for 125 years. (Courtesy J. B. Watkins Elementary School.)

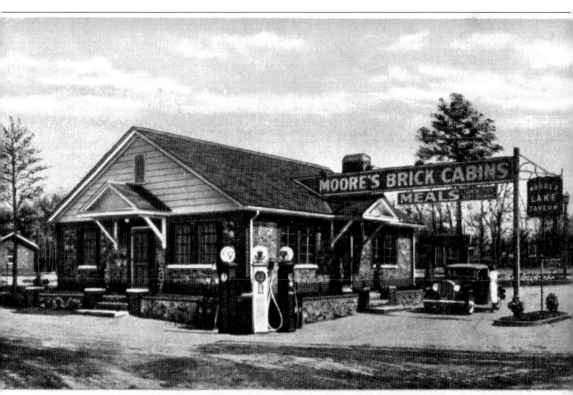

MOORE'S BRICK CABINS AND DINING ROOM, P.O. CHESTER, VA.

Moore's Brick Cabins and Dining Room was located 12 miles south of Richmond on U.S. Route 1 in Chester. The property was equipped with "bath, garage, steam heat, shady grove, bathing and modern air conditioned restaurant." Travelers could stop on their trip along the East Coast. The motel was run by Mr. G. C. Crump. Highlights advertised on the back of this postcard included, "All beds equipped with inner spring mattresses."

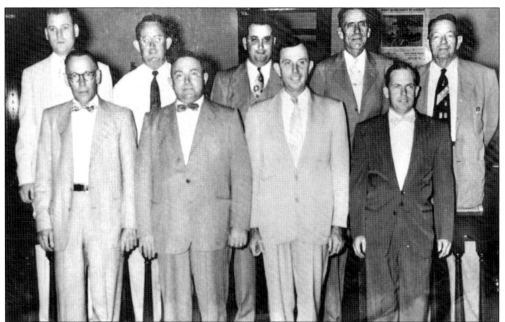

In 1955, the Chesterfield County Police Department had a fully staffed detective division. Pictured here are, from left to right, (first row) Chief C. W. Smith, Edgar P. Gill, Robert Feeback, and Mark Wilson; (second row) Z. G. Davis, Benny Lane, Charlie Richter, Raymond Koch, and I. E. Bowman. (Courtesy Chesterfield Historical Society of Virginia.)

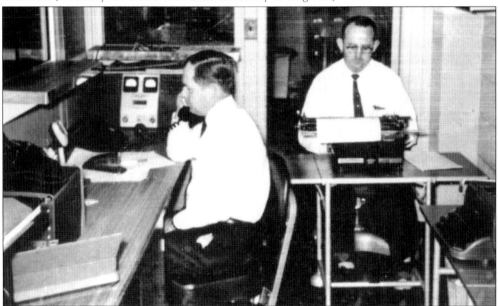

The first communication center for the county was established in the old county jail. In 1944, the building was remodeled, and the first floor became police headquarters. In 1945, the board of supervisors approved the purchase of two-way FM radio equipment on all police cars and a transmitter and receiver at headquarters. A police communications antenna was built behind the jail. Pictured in 1958, using manual typewriters, radios, and telephones, Benjamin S. Lane (left) and Mark E. Wilson work in the center. (Courtesy Chesterfield Historical Society of Virginia.)

The county board of supervisors elected in 1940 was made up of a number of prominent businessmen in the area. The members pictured are shown at their first meeting on January 11, 1940. They are, from left to right, (first row) Harold Goyne (Bermuda), Peter Covington (Matoaca), T. D. Watkins (Midlothian), W. A. Horner (Manchester), and James G. Hening (Dale); (second row) Horace Chalkley (Clover Hill). (Courtesy Chesterfield Historical Society of Virginia.)

Sen. Lloyd C. Bird served the county as a state senator from 1944 until 1972. He was born in Highland County, Virginia, on August 1, 1894. He was a teacher at the Medical College of Virginia before he started his political career. In the early 1920s, Bird started a business with Morris Phipps selling laboratory equipment and other products for scientific use. He held the position of president of the Virginia Academy of Science for one year in 1952. Lloyd C. Bird High School in Chesterfield County was named in his honor. (Courtesy Chesterfield Historical Society of Virginia.)

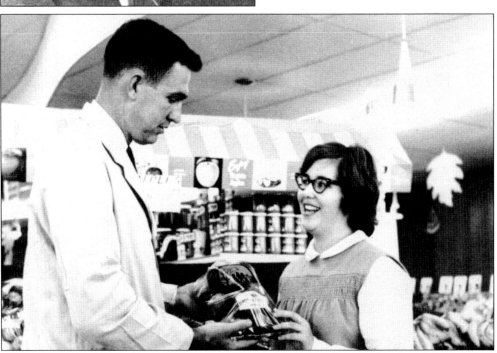

Ukrop's is a chain of grocery stores throughout the Richmond area known for their values and service. The first store was opened by Joe Ukrop in 1937. Many stores followed over the years, and his family still runs them today. Pictured here in 1965 are Martha Rice, a sophomore at Midlothian High School, talking with manager Brent Holder. (Courtesy Dale Paige Talley.)

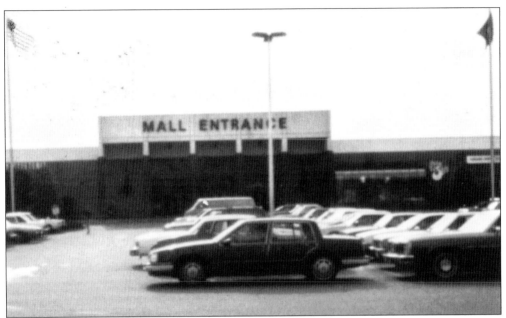

For many years, Southside Plaza was the shopping center of Chesterfield County. In the early 1970s, that all changed with the construction of Cloverleaf Mall. The mall, located at the intersection of Midlothian Turnpike, Route 60, and Chippenham Parkway, was the first mall in the area. The anchor stores when it opened were Sears, J. C. Penney, and Thalhimers, and there was a two-screen movie theater. The county benefited greatly from the increased tax base, as Southside Plaza, another major shopping facility, had been annexed recently by the City of Richmond, and the county had lost the tax revenue. (Courtesy Chesterfield Historical Society of Virginia.)

Cheatham's Furniture was located in Manchester. This picture, taken around 1900, shows wood-burning cook stoves on display for sale. The man on the left is Thomas J. Stanley. (Courtesy Chesterfield Historical Society of Virginia.)

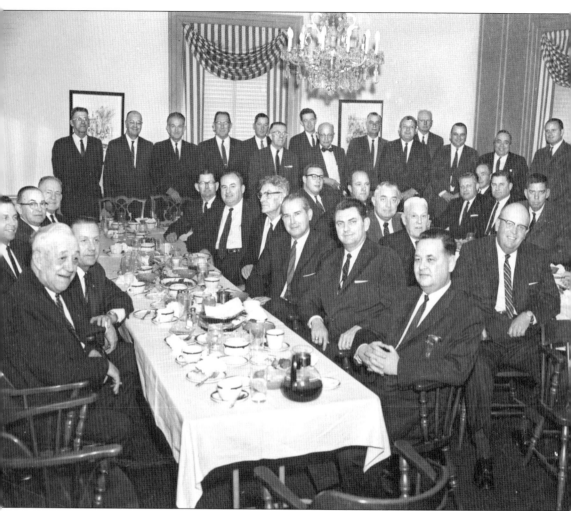

Pictured in 1966 is Harold T. Goyne Jr.'s annual wild game festival dinner, held at the Indian Hills Motel off Interstate 95 at the Walthall exit. Included here are Fred Shepherd, Harold T. Goyne Jr., Alex Goyne, Edgar P. Gill, C. C. Wells, Raymond Britton, George W. Moore Jr., Dewey Mullins, Dabney Lancaster, R. A. Painter, Harold T. Goyne, Howard A. Mayo Jr., Judge William Old, Judge D. W. Murphy, Irvin C. Horner, Andrew R. Martin, Jerry Jewett, R. Pinkney Sowers, M. P. Burnett, H. O. Browning, Judge Ernest P. Gates, H. M. Shoosmith, H. B. Walker, Treasurer of Virginia Lewis Vaden, Judge William R. Shelton, Oliver D. Ruby, Leo Myers, J. R. Apperson, O. B. Gates, W. Hugh Goodwyn, Roy Alcorn, and William R. Maxwell, Mack Daniels, and Bruce Sowers. (Courtesy Chesterfield Historical Society of Virginia.)

Two

FRIENDS AND NEIGHBORS

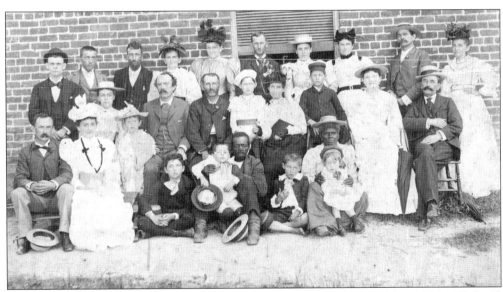

The Winfree family held a reunion in 1890. Included in this picture are Mr. and Mrs. Philip V. Cogbill, S. Edith Winfree, Hugh Cabell Winfree, W. Ashton Winfree, William Archer (servant), M. Wyville Winfree, T. Merrille Winfree, Jo Anne Archer (servant), Colon Gregory, Mrs. May Moody Winfree, Mr. and Mrs. Mac Cogbill, Mr. and Mrs. Rupert W. Winfree, Pearl Winfree, Rieves W. Winfree, Berta Winfree, Judge W. I. Clohton, T. Edwin Winfree, Mr. and Mrs. T. Marion Winfree, Eddie Hatcher, Mrs. Mattie Gill Goode, Judge and Mrs. J. M. Gregory, and Fannie Winfree. (Courtesy Chesterfield Historical Society of Virginia.)

Magnolia Grange was a plantation home located on Route 10 across from the courthouse. Several of the first families of Chesterfield have lived here. William Winfree was the builder of the home, and the DuVals owned it at one time. The Cogbills owned the house for many years after the DuVals. Pictured here from left to right are Mable T. Cogbill (Mrs. Walter Perdue), Virginia Jeffs ("Ginny"), and Mary Proctor. (Courtesy Chesterfield Historical Society of Virginia.)

Castlewood, the present-day home of the Chesterfield Historical Society, was once the regal home of Parke Poindexter. He was the clerk of the court for the county. This home is unique in that it is one of only two homes in the county that had a finished room in the basement. In 1860, Trinity Methodist Church owned it and used it as a parsonage for 12 years. In the 1920s, it was owned by James E. Lumpkin, who is attributed with naming it Castlewood. In 1976, Heritage Savings and Loan Association bought the property and used it as a branch. (Courtesy Chesterfield Historical Society of Virginia.)

In the late 19th century, schoolchildren in Bon Air would walk to school winter and summer. Pictured here were two students, Helen Hardy (left) and Hunter Sutton (right), who lived in the area. This photograph, taken near the community center, was done to illustrate a primer. Helen Hardy grew up to become the wife of Dr. Moreland of Randolph-Macon College. (Courtesy Bon Air Public Library.)

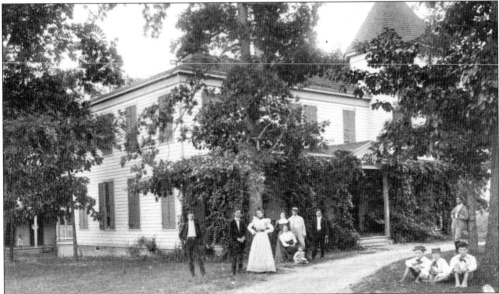

The Sutton House in Bon Air was built in 1883 by Samuel A. Ford and his wife. They chose a parcel of land on part of what was the Kilbourne Plantation. After Mr. Ford died, the house was sold to Ida Stegar and in turn to Mr. and Mrs. Frank Taylor Sutton and their seven children. Mr. Sutton owned a real-estate firm and lived at the house. They worked the land and grew their own grapes for wine. The Cox family moved in the early 20th century, and a final owner, Percy Glinn, sold it to the Bon Air School for Girls in the 1920s. It was finally torn down in the 1950s. (Courtesy Chesterfield Historical Society of Virginia.)

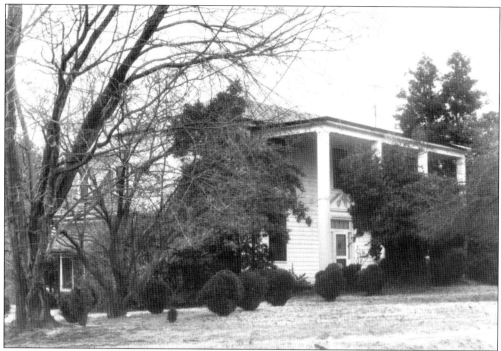

Warfield, an estate built in 1749 in Chester, was owned by John Perdue along with two of his brothers. John Perdue was the grandfather of Landon Perdue. During the Civil War, the house was confiscated by General Butler's Union troops and converted into a hospital. After the war, it was occupied by family members. Eventually it was sold to Bobby Goyne, who tore it down in 1979. (Courtesy Chesterfield Historical Society of Virginia.)

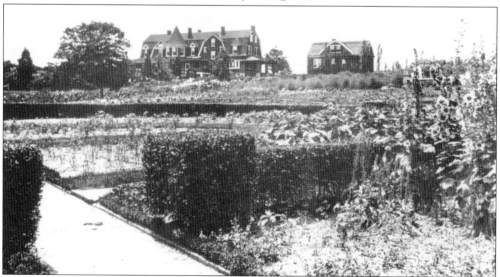

Miniborya was located near what is now the Meadowbrook golf course. It was built in the late 19th century by a local businessman, J. Scott Parrish. He was the founder of the Concrete Pipe and Products Company. The house and its gardens were considered some of the best in the area. Parrish and members of his family lived in the house through the 1960s. In 1973, it was torn down to make way for apartments. (Courtesy Chesterfield Historical Society of Virginia.)

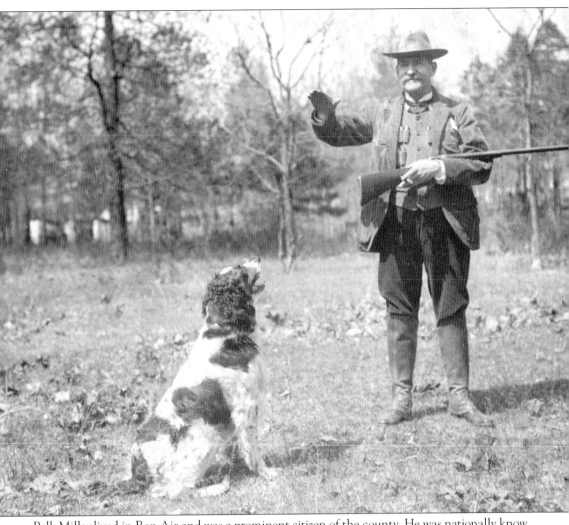

Polk Miller lived in Bon Air and was a prominent citizen of the county. He was nationally know for his lectures and concerts about the Old South, even traveling to Europe to entertain crowds of people wanting to know what the South was like before the Civil War. However his real profession was as a pharmacist. He had been developing products to help the hunting dogs of his friends, and this grew into a profitable business that became Sergeant's Pet Care. It was named after his favorite dog. (Courtesy Bon Air Public Library.)

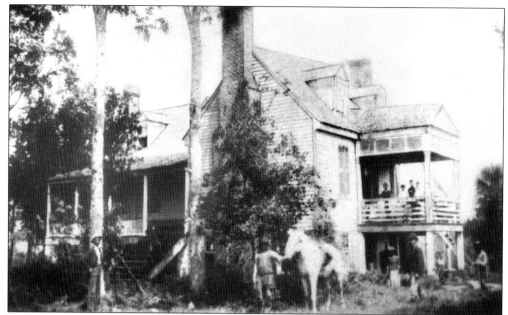

Physic Hill was owned before 1820 by Dr. John R. Walke. His sons, Dr. Sydenham Walke and John Walke, continued to live there after his death. In 1883, the property was acquired by Dr. J. E. Holmes, a doctor from Maryland. Because of the number of physicians that occupied the residence, it received its name. (Courtesy Chesterfield Historical Society of Virginia.)

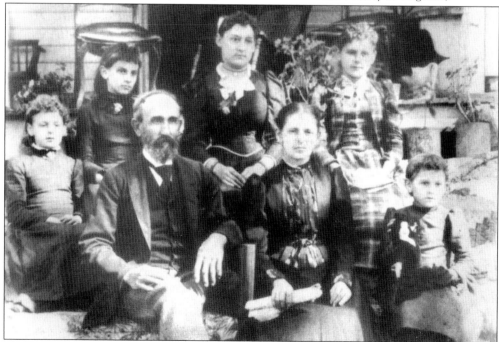

The Holmes family lived at Physic Hill for many years beginning in 1883. Dr. J. E. Holmes, pictured here, was on the board of supervisors for Chesterfield County from 1897 until he died from a sawmill accident in 1900. The Holmes family is pictured here. (Courtesy Chesterfield Historical Society of Virginia.)

James Beauregard Rudd Sr. was born on July 24, 1861, and raised in Chesterfield County. His parents, James Rudd and Harriett Allen Worsham, were also born and raised in the Skinquarter area. Rudd Sr. was a superintendent for the J. B. Lightfoot Tobacco Company. He passed away on March 30, 1912, and is buried in Maury Cemetery in south Richmond. (Courtesy Jerry Rudd.)

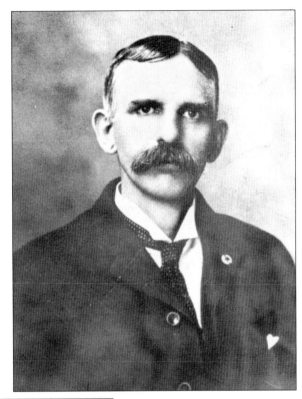

Mrs. Vania Ermine Rudd was a devoted housewife and mother who was married to James Beauregard Rudd Sr. Born August 24, 1866, and raised in the Skinquarter area, she is pictured here in the 1920s. She passed away on September 6, 1932. (Courtesy Jerry Rudd.)

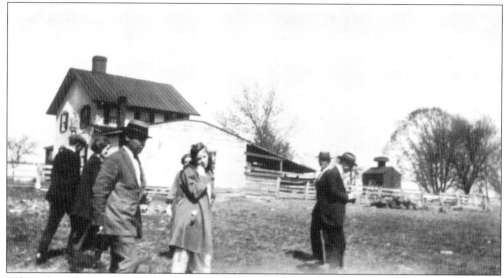

When the colonists traveled up the James River led by Sir Thomas Dale to find a better place to settle, they came upon Farrar's Island. It became the second English colony in the New World. Similar to Jamestown in its ability to be fortified because it was an island, Farrar's Island was to be the site of the first college and hospital in the New World. In 1924, a farm was located on the island called Flippo Farm. Here on Easter Sunday, friends and family gather to celebrate the day. The man in the foreground at left is Wallace Graves. (Courtesy Chesterfield Historical Society of Virginia.)

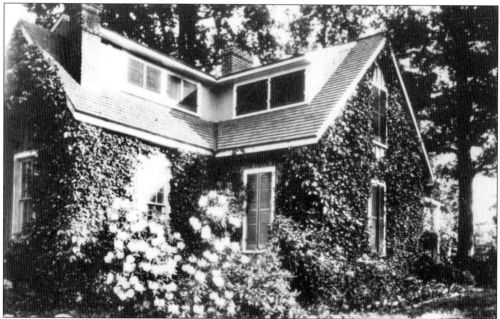

Buckhead Springs, located near Centralia, was part of the old upper Paradise Plantation. It was the home of Thomas S. Wheelwright and his family. Wheelwright was known as one of the foremost respected industrial leaders of Virginia. He was president and director of Virginia Railway and Power Company and Old Dominion Iron and Steel Works. (Courtesy Chesterfield Historical Society of Virginia.)

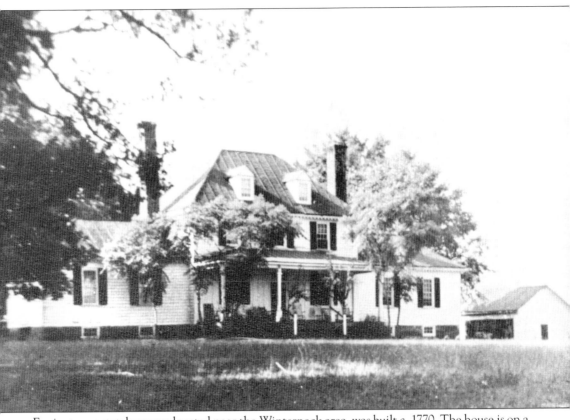

Eppington, a stately manor located near the Winterpock area, was built c. 1770. The house is on a ridge overlooking the Appomattox River. Francis Eppes, the builder and first owner, was considered one of the wealthiest men in the county. He and Thomas Jefferson were brothers-in-law as they were married to half sisters, the daughters of John Wayles. When Jefferson was ambassador to France, he brought his daughters to Eppington to stay with the Eppes family. One of girls passed away and was buried here. In 1862, the property was sold to Henry Cox. In 1876, Williams Hines acquired the house and grounds and renovated it to its original splendor. (Courtesy Chesterfield Historical Society of Virginia.)

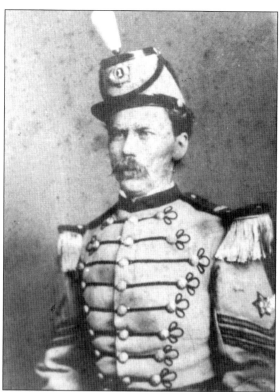

George Edwin Ruffin was born May 3, 1848. It is believed he built the Ruffin Home, located at 4220 West Bermuda Hundred Road, in 1890. He was a member of the First Battalion, Virginia Infantry, as an enlisted soldier. He married Ada Cora Harding on October 1, 1885. He worked after the war as a shop manager for the Tidewater and Western Railway Shops in Chester, Virginia. He died on October 24, 1907. (Courtesy Chesterfield Historical Society of Virginia.)

The Huguenot House, seen in this picture, was most likely built by Francis Flournoy in the 19th century. He was the son of a Huguenot refugee, Jacob Flournoy. The land was bounded by Swift Creek, Tomahawk Branch, and Nuttree Branch. The house was demolished in 1929 by Guy M. Cheatham in order to build a new house. (Courtesy Chesterfield Historical Society of Virginia.)

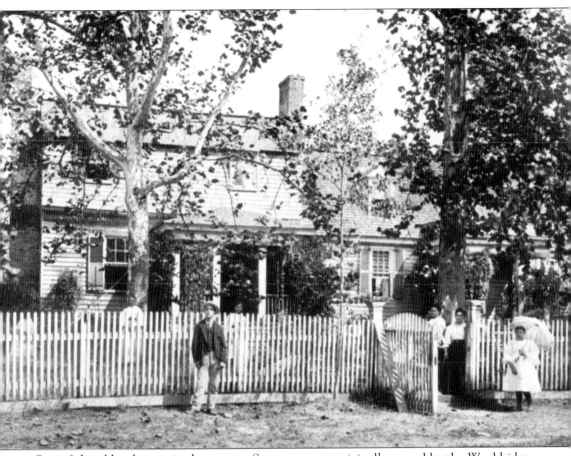

One of the oldest houses in the county, Sycamores was originally owned by the Wooldridge family, who ran several coal mines in the area. It served as a tavern for a time in the early 19th century. A well-respected doctor, Dr. Jefferson Hancock, a descendant of the Wooldridges, lived here after the Civil War and practiced medicine in a small building in the back. In 1875, John W. Jewett bought the house, and his wife, Mary Ann Jones Jewett, ran it as a summer boarding house in the late 19th century. The Jewetts are pictured here from left to right: Margaret Jewett Fisher, David Jewett, Mary Jones Jewett, Annie Jewett Bishop, and Mary Jewett Field. After its sale in 1975, Sycamores was occupied by several eateries before becoming a restaurant called Crab Louie's Seafood Tavern in 1981. (Courtesy Chesterfield Historical Society of Virginia.)

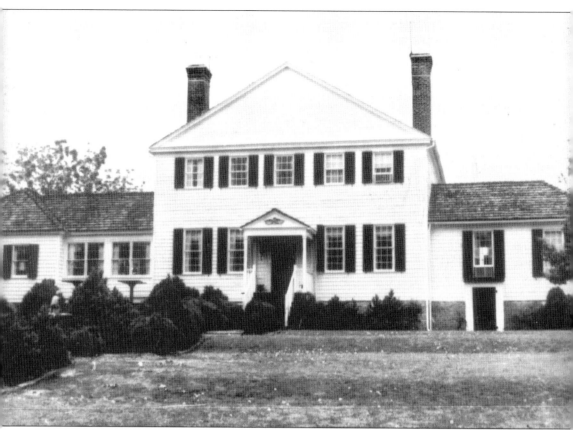

Roger Atkinson I came to the county to set up a tract of land to be used as a home for his son, Roger Atkinson II. The house, which sat on a bluff overlooking the Appomattox River, was built in the mid-18th century; Roger II lived here until he died in 1829. Roger Atkinson II was a justice of the peace in the area as well as owning farms in the western part of the state and a mill south of Olive Hill. He spent much of his time working to improve the quality and access to the Appomattox River, which flowed below the house. When he died, his widow continued to live in the house until 1833, when ownership transferred to the husband of one of the Atkinson daughters. By 1946, it had been owned by several other people and had fallen into disrepair. John A. Christoffel purchased the house and property and began much-needed renovations. There have been several other owners since the 1940s. (Courtesy Chesterfield Historical Society of Virginia.)

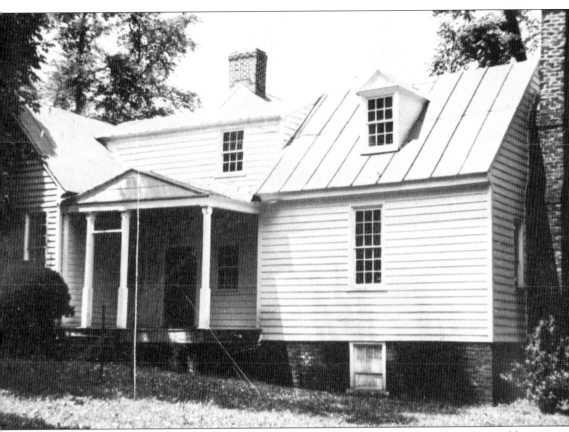

Clover Hill Plantation, located in the Winterpock area, was home to James Henry Cox and his wife, Martha Reid Cox. He had been given the land by his father, Henry Cox, when he returned after graduating from Hampden-Sydney College in 1829. He had studied law and for a time taught at a school in Florida. But when he returned, his focus would change. While it was not fertile land, the discovery of coal on a hillside would change the community forever. A railroad was built to transport his coal, so much that it was being transported not just in Virginia but up the Eastern Seaboard. Much of the coal was used to help the Confederate cause in the ironworks in Richmond. During the war, the Cox family hosted a dinner for Gen. Robert E. Lee and his officers in their home. Judge Cox, as he would become when he was appointed the first judge in the county in 1871, died in 1877. The home stayed in the Cox family until the 1920s. (Courtesy Chesterfield Historical Society of Virginia.)

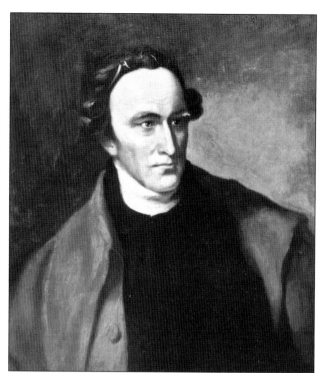

Patrick Henry was a patriot, governor, and Virginian. He served several terms as governor, and for the latter part of that time he lived at Salisbury with his family. He was there from 1784 to 1786. (Courtesy Chesterfield Historical Society of Virginia.)

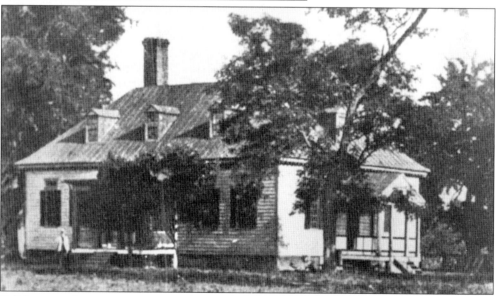

Salisbury was home to governors and generals. It was built by Thomas Mann Randolph in the mid-18th century to use as a hunting lodge. It is not clear how often he used the house, but he did rent the home to Patrick Henry during his term as governor. After Patrick Henry left, Randolph sold the property to Dr. Philip Turpin, and it passed down to his daughter, Caroline Johnson, the wife of Dr. Edward Johnson. In 1843, it was again passed down to their son, Gen. Edward Johnson. He lived there for the rest of his life. In 1923, the house burned to the ground. In the 1960s, a group joined together and built the Salisbury Country Club on the site, which looks similar to the original house. (Courtesy Chesterfield Historical Society of Virginia.)

The Phillips family has lived in the area for many years. Included in this early-20th-century picture are Dee Phillips, Clinton Phillips, Richard Phillips, Copland Phillips, Inez Phillips, Hattie Phillips, Rena Phillips, Ida Phillips, Irving Phillips, Julian Phillips, and Martha Phillips. (Courtesy Chesterfield Historical Society of Virginia.)

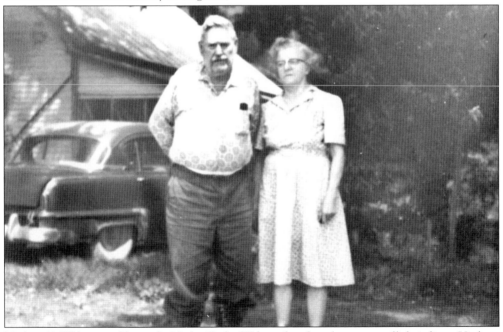

Herbert E. Wilson and his wife, Madge Ryder Wilson, lived in the county all their lives. Herbert was born August 25, 1896, and he died September 4, 1972. Madge was born March 27, 1896, and died October 5, 1981. They lived on their farm on Bundle Road near Beach, where Herbert was a tobacco farmer. He also was a hunting and fishing enthusiast. They had five children: Elmer D. Wilson, Mark Wilson, Edith Wilson, Eileen Wilson, and Herbert Wilson Jr. (Courtesy Edith Wilson.)

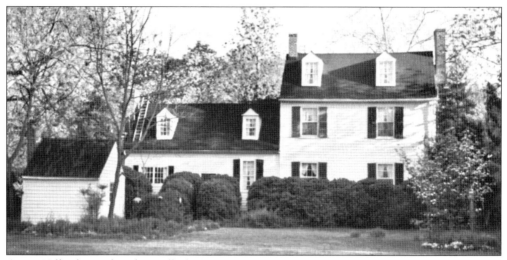

Aetna Hill is located in the Midlothian area. It was originally a one-and-a-half-story, Huguenot-style house with two front doors. It was built by Thompson Blunt for his bride, Frances Morrissett, who was a descendant of one of the original Huguenot settlers of the area, Pierre Morriset. Their daughter, Maria Louise Blunt, married Elijah Brummall and was given the deed to the land. In 1847, a larger section was added, and the existing structure was altered so that it looked more as it does today. At one time, the Blunt-Brummall Aetna coal mines were very productive. Aetna Hill passed from generation to generation. In the late 19th century, Brummall's granddaughter Maria P. Watling and her husband, Robert H. Winfree, owned the house. Their granddaughter Betty Weaver is the current owner. (Courtesy Bettie Woodson Weaver.)

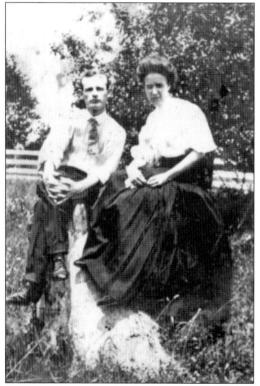

Bettie Haskins Winfree and Thomas Callen Woodson were married on June 26, 1907, at 8:00 p.m. at the Bethel Baptist Church. The Reverend Robert Winfree, the bride's father, officiated, as well as Dr. William E. Hatcher and Rev. Charles A. Woodson, the groom's father. They are pictured on the day of their wedding at the apple orchard beside Aetna Hill, the Winfrees' family home. The couple had met in Nottoway, where Bettie was teaching school. She had gone to Fork Union to attend high school in her youth and then, in 1904, graduated from the Woman's College, forerunner of Westhampton College of the University of Richmond. (Courtesy Bettie Woodson Weaver.)

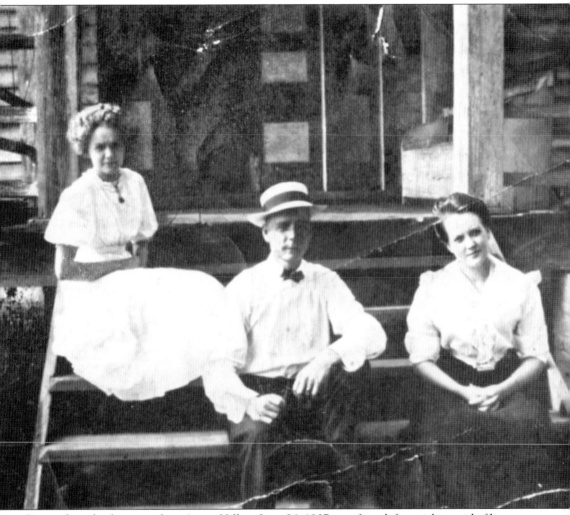

Pictured on the front porch at Aetna Hill on June 26, 1907, are, from left to right, maid of honor Emma G. Winfree, groomsman D. Basil Winfree, and bride Bettie H. Winfree. (Courtesy Bettie Woodson Weaver.)

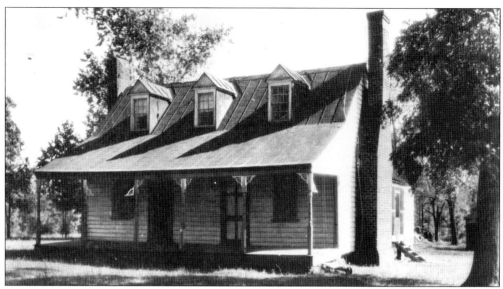

Adventure Hill was built in 1847 east of Winterpock and owned for many years by the Pinchbeck family. William Pinchbeck was a successful farmer who also ran a gristmill on Sirloin Branch and a general store located in front of his house. In the 1930s, John Norvell purchased the property and did some renovations. (Courtesy Chesterfield Historical Society of Virginia.)

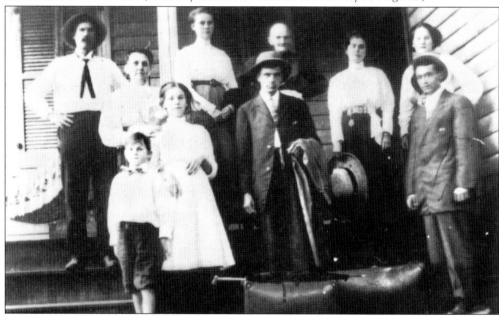

Spring Hill is located near the mouth of Proctors Creek. The Gregory family lived there through the late 19th century, when it was sold to E. T. DuVal and J. F. DuVal. Later owners were the Davis family and finally Judge and Mrs. Dwight W. Murphy. The Murphys sold the property to Reynolds Metals in 1956 to be used as a test site for metal products. Pictured here in the early 20th century is the DuVal and Morris family. Included are Lula Hunter DuVal, Ralph Guy DuVal, Carl Edward Sherman, Russell Fisher Dibrell Morris, Mrs. Ada Morris DuVal, Mary Lee DuVal, Phail Gertrude Conley, Mrs. Bettie Gibson Morris, Bettie Claire DuVal, and Frank Nelson. (Courtesy Chesterfield Historical Society of Virginia.)

Mrs. Glenna Loving Norvell inherited Adventure Hill and did extensive renovations. Her husband was John E. Norvell. She is pictured here with her dog. (Courtesy Chesterfield Historical Society of Virginia.)

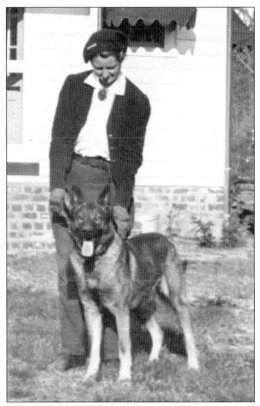

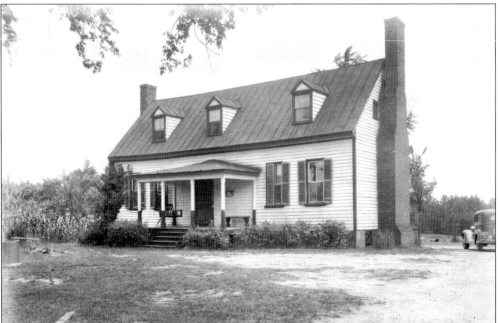

Pictured here is a house typical of those built in the Skinquarter area of the county. The area served as the westernmost stop for the railroad; travelers frequented the taverns and would stop on their way west to rest their horses. (Courtesy Chesterfield Historical Society of Virginia.)

Otterdale Farm was home to a number of families during its existence. The original owner, Col. Woodson Wingfield, built the house before 1834. He was in the county regiment as well as being a politician and agriculturist. He had one of the most successful and productive farms in the state. His tobacco was highly coveted. In the late 19th century, two brothers, John Lewis Waltman and Wallace Waltman, bought the farm for $4,500. The brothers and their families lived there. When John Waltman moved to Pennsylvania, another friend of the family, Willie Mead, moved in. Wallace Waltman married Willie Mead's sister, and Willie Mead married a local girl named Lizzie Winckler. John Waltman and his family of three children came back to stay. Wallace and John's mother and second husband came to live there as well in 1897. Other homes were built on the property for Waltman family members, and they lived there until 1933, when the house burned to the ground. (Courtesy Chesterfield Historical Society of Virginia.)

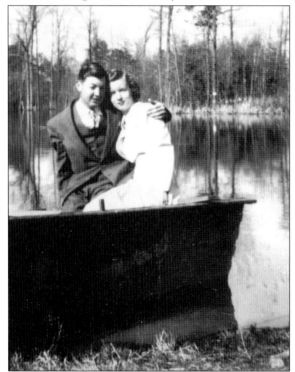

Edith Wilson of the Beach area is seen here with her future husband, Lawrence Hobbs, in the 1940s. She was from a family of five children, and her parents, Herbert and Madge Wilson, lived on Bundle Road. They are seen in a boat in Dinwiddie County for an afternoon boat trip. (Courtesy Edith Wilson Hobbs.)

The Chester Pharmacy was located at 4301 Old Hundred Road. Originally a one-story structure, the pharmacy was first run by Mr. Richardson in the early 20th century. However, in 1911, Dr. Andrew T. Organ became the owner and ran the store for the next 20 years until his death. The store served as a ticket station when the trolley traveled past it from Richmond to Petersburg. In 1910, it was enlarged, and the post office for Chester occupied space in the building. Dr. Organ at that time also became the postmaster. Until the 1930s, it served the community, and in the late 1930s, the original structure was moved across the street. It was later torn down. (Courtesy Chesterfield Historical Society of Virginia.)

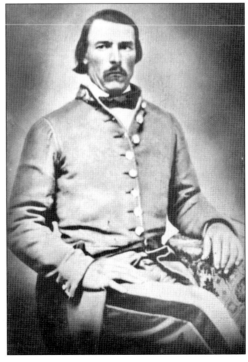

Thomas Edward Bailey was born in Chesterfield County on November 19, 1829, at his family's home on Genito Road. He is pictured here in his Confederate uniform. He served in the Confederate army with the 6th Virginia Regiment, Company K, and was killed in battle on August 10, 1864. He was buried at his birthplace. Bailey had a son, Thomas Edward Bailey Jr., who lived in Chesterfield on Otterdale Road, married Lucy Horner Bailey, also of Chesterfield, and worked for the railroad. (Courtesy Chesterfield Historical Society of Virginia.)

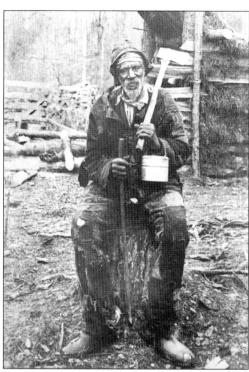

Old Ben was a wood chopper in the area. This picture was taken in the late 19th century. (Courtesy Chesterfield Historical Society of Virginia.)

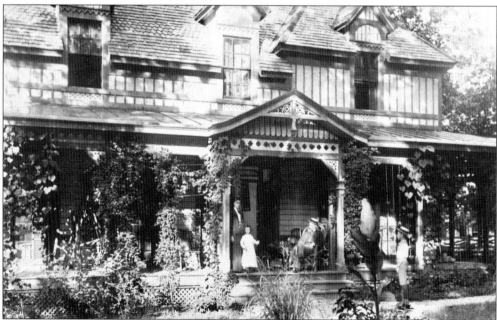

In 1883, Maj. Robert Stiles built a cottage with very unique detailing on the outside of the house. He named it Dinglewood. Major Stiles studied to be an attorney and was very active in politics. He was president of the Prison Association for Virginia. The family lived at this house three months out of the year, since their primary residence was on Franklin Street in Richmond. However, when he passed away, his children, Evelyn Stiles and Joe Clay Stiles, moved into the summer home on a permanent basis. (Courtesy Bon Air Public Library.)

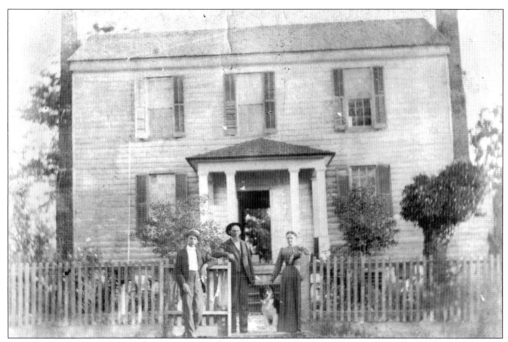

Dunston Farm was located at 13902 Nash Road. It was built before 1820 and stood on 951 acres of land. John N. Dunston bought the house in 1952. The Dunston family in the photograph are, from left to right, Willima N. Dunston Sr., John N. Dunston, and Mrs. John N. Dunston, formerly Lorena Frances Gill (sister of Sheriff Gill). (Courtesy Chesterfield Historical Society of Virginia.)

On a warm afternoon, Martha Gertrude Gill Lush is seated with her children around her. They lived on Coalboro Road at Winterpock between the Tabernacle Church and River Road. She was born in 1876 and died in 1965. The twins on her lap are George Ben Lush and Gertrude Lush. They were born in 1908, and Gertrude died in 1909. Standing beside Mrs. Lush are Emily D. Lush, born 1898, and Herbert Linwood Lush, born 1905. She was the wife of Dr. Herbert Bolton Lush, a respected doctor in the area who delivered many people in the community. (Courtesy Chesterfield Historical Society of Virginia.)

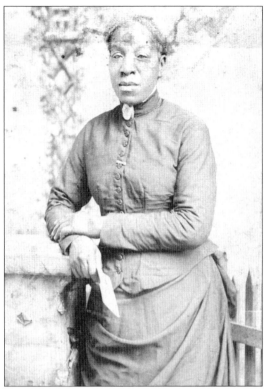

Keziah "Kizzie" Harris was born in 1835 at Aetna Hill. She lived there throughout her life as a family servant in the Brummall-Winfree family. She helped raise the children and lived in a small house on the grounds. This picture was taken at the studio of C. R. Rees, a well-known photographer in Petersburg. Kizzie passed away at Aetna Hill in the early 20th century. (Courtesy Bettie Woodson Weaver.)

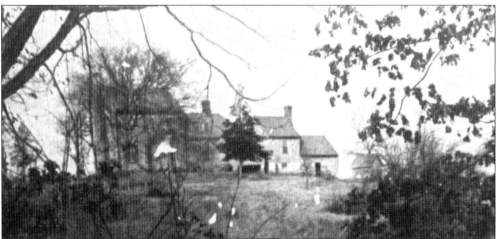

Rattlesnake Spring Farm was a large tract of land spanning from south of Forest Hill Avenue to Burroughs Street. The house, probably built in the mid-18th century, was owned by Obadiah Smith. After his death in 1808, the land was divided among his heirs, and the property where the house stood was sold to John Harris. He renovated the house and called it Rattlesnake. It in turn was sold after his death to William I. Fore in 1847. Fore lived here during the Civil War and afterwards allowed his servants to use part of the land until they could afford to buy it. He then sold a large part of the farm to a company with plans to develop a new resort community. That community became Bon Air. The last owner was Sol Haas, an executive with the Richmond and Danville Railroad. The house burned to the ground in 1925. (Courtesy Chesterfield Historical Society of Virginia.)

Stoney Point Plantation was the home for many years of Mrs. and Mrs. Lewis G. Larus. Mr. Larus, pictured here, was the owner of Larus Tobacco Company. The original home he had bought was Victorian and had been built by Dr. John W. Bransford in 1889. Dr. Bransford, a retired naval veteran, built his home so that it had views of Richmond and the mountains. It is reported that while living there, Dr. Bransford's two sons drowned at Boshers Dam, along with a servant who tried to save them. The Larus family lived there until 1924, when the house burned to the ground, and they rebuilt the estate in the Tudor style in 1925. Mr. Larus died in 1966, and the house became the Stony Point School. It remains a school to this day. (Courtesy Chesterfield Historical Society of Virginia.)

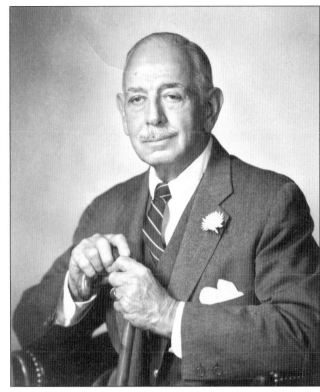

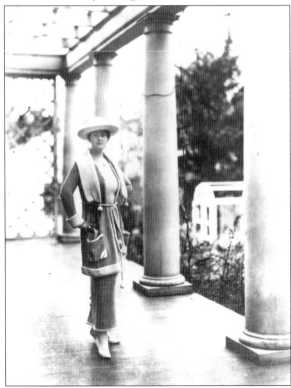

Part of the charm of Stony Point Plantation was its beautiful gardens. Mrs. Ann Gavin Traylor Larus, pictured here, was the wife of Lewis G. Larus. She and her husband created a home with spectacular views, lovely gardens, a working farm, and a large family. The Laruses had six children—John Baldwin Larus, Michael Gavin Traylor Larus, Robert Lee Traylor Larus, Roberta Larus, and twins Cornelia Larus and Lewis Larus Jr. Mrs. Larus's gardens were designed by Charles L. Gillette, a prominent landscaper of the day. He used bricks, stones, and other interesting items to create a tranquil place to walk and read. It took over 20 years before the gardens were complete. (Courtesy Chesterfield Historical Society of Virginia.)

Angus Goode is pictured here near his home around 1926. He is being held by his friend "Li'l Kiah" Rudd. Kiah also has a new puppy. Angus was born in 1925 and was the founder of the Chesterfield Berry Farm as well as being the owner of a dairy farm. The farm was located off Route 60 in the western part of the county. He passed away in 1989. (Courtesy Chesterfield Historical Society of Virginia.)

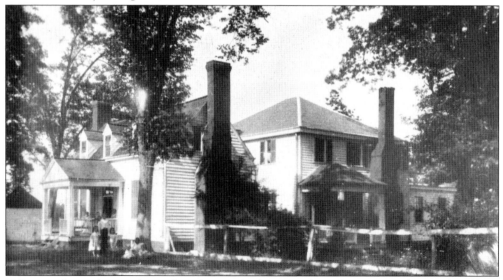

Kilbourne, located in southwest Bon Air, was built in 1823 by Robert D. Murchie. He lived here until his death in 1841. His widow renovated the home, and in 1874, it was sold to Nicholas Mills. After several more owners, it was sold in 1909 to the Virginia Home and Industrial School for Girls. After a rocky start with private ownership, the home was taken over and run by the state. The school grew, acquiring more land, and in the early 1960s was renamed the Bon Air Learning Center. (Courtesy Chesterfield Historical Society of Virginia.)

Bessie Cook and Augusta Barfield are seen here in the garden of the Cook House in Bon Air. Many of the women who lived in the area were very diligent in the design and care of their gardens. Miss Cook and Miss Barfield ran a kindergarten in the early 20th century for children of the community. This house was located at 8528 Hazen Street. Miss Barfield was a cousin of the Cook family and lived in their house. (Courtesy Bon Air Public Library.)

Cottage Grove was built about 1796 in the Skinquarter area. John Bass was the original owner who built the house. It was near Goode's Bridge, which is now Hull Street (Route 360). The house and property were owned by a number of people. The last occupant of the estate was C. G. Millard, who lived here in 1933. Shortly after that, the building was torn down. (Courtesy Chesterfield Historical Society of Virginia.)

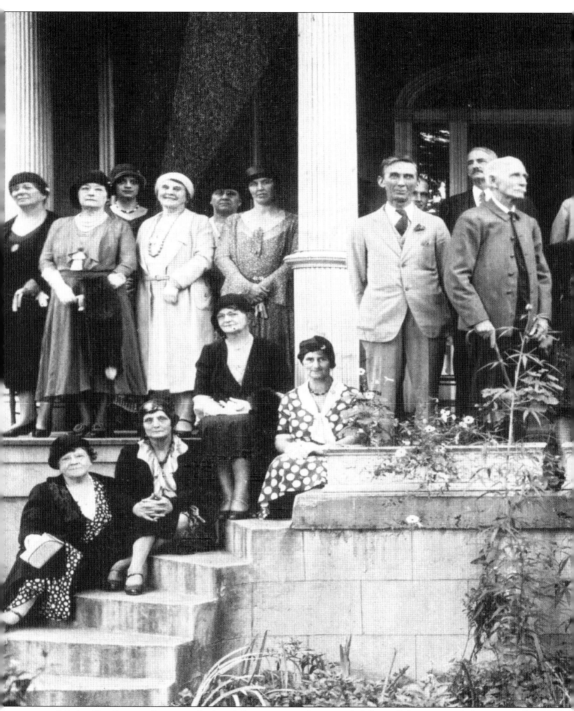

Violet Bank was the site of a birthday party in honor of Admiral Semmes of the Confederate States of America (CSA). On September 27, 1931, a large group of people gathered to celebrate the event. From left to right are (seated) Mrs. A. K. Davis, Anne V. Mann, Mrs. ? Frey, May Dewberry and two unidentified children; (standing) Mrs. W. W. Hines, Mrs. J. R. Bell, Mrs. ? Perkinson, Mrs. W. C. Powell, Mrs. J. J. Nelms, Mrs. Van Jordan, Samuel D. Rogers, Van Jordan,

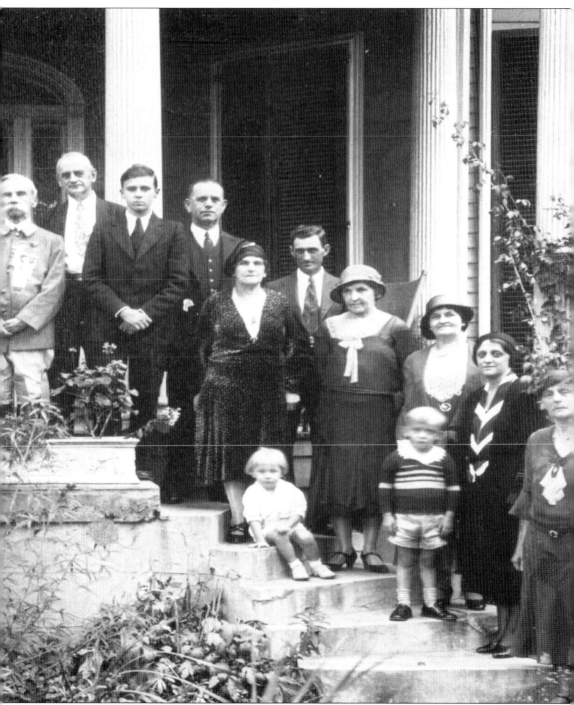

Homer Atkinson (CSA), Mrs. T. J. Moran, ? Phieffer (Methodist minister), Capt. Carter Bishop (CSA), Dandridge Spotswood, "Young" Atkinson, unidentified, Mrs. Gertrude Duncan Dinwiddie, Macon Cole, Mrs. Louise Duncan Cunningham, and Mason Cole Jr. (Courtesy Chesterfield Historical Society of Virginia.)

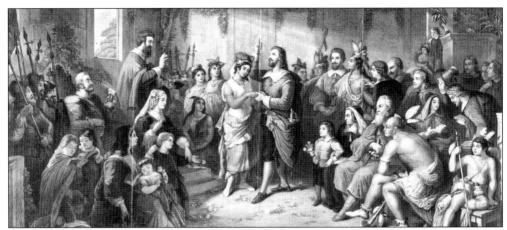

The marriage of Pocahontas, daughter of the Indian chief Powhatan, and John Rolfe was a major factor in the peace and friendship that the colonists and the Native Americans of the area enjoyed for eight years. In 1614, they were married and lived in Bermuda Hundred at Rolfe's home, Varina, for a short time. John Rolfe was instrumental in developing, planting, and promoting the growth of the tobacco crop in Chesterfield. He used seeds obtained from the West Indies that worked well in the climate of Virginia. After a trip to England where Pocahontas died unexpectedly, he returned to America and continued farming until he died around 1622. (Courtesy Chesterfield Historical Society of Virginia.)

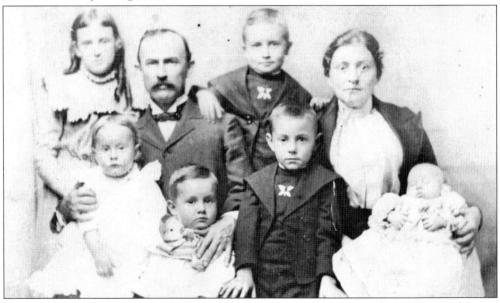

Philip Valentine Cogbill was born January 24, 1861, the only son of Mr. and Mrs. W. W. Tilghman Cogbill. They lived a mile from the Chesterfield Courthouse. His father was killed in the Battle of Gettysburg during the Civil War. Cogbill grew up to a life of public service. He was deputy clerk of Chesterfield for a time before he was elected commonwealth's attorney in 1887. He was later elected state senator and then became the clerk for the county in 1904 and served in that capacity until 1940. He is pictured here with his wife, Julia Trueheart, whom he married in 1886. Their children are, from left to right, Kathryn Cogbill, Mabel Cogbill, Philip H. Cogbill, Marcus A. Cogbill II, William Tilghman Cogbill, and John Valentine Cogbill. (Courtesy Chesterfield Historical Society of Virginia.)

Three

A MILITARY PRESENCE

Chesterfield County played a major role in the Revolutionary War by helping provide trained fighting men for the cause. It had been decided that Chesterfield Courthouse would be a central point for residents to come and sign up to fight. In 1780, Maj. Gen. Peter Muhlenberg began recruiting men and by the later part of that year had successfully gotten 3,000 recruits. In December, it fell upon the hand of Baron Friedrich von Steuben, pictured here, to set up a training post and prepare the men for combat. He had been a drillmaster at Valley Forge and was well suited for the task. He took over as commander for Virginia. He supervised the addition of buildings and a hospital. During his command, his recruits helped defend the county as well as being sent to other parts of the country under attack. (Courtesy Chesterfield Historical Society of Virginia.)

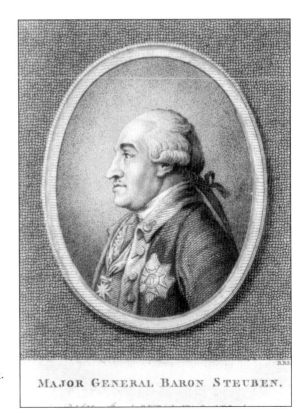

MAJOR GENERAL BARON STEUBEN.

During the Revolutionary War, homes in the county were sometimes taken over by British soldiers as they traveled from north to south. This house, owned by James Wiley Winfree near Broad Rock, was no exception. Gen. William Phillips, a British officer, kept his troops on the grounds of this house. The name "British Camp" was attached to the house after that incident. The house was later moved to Goochland County. (Courtesy Chesterfield Historical Society of Virginia.)

The Civil War was devastating to many areas of the county. Buildings were burned and heirlooms were stolen. When the Union troops came to the Chesterfield Courthouse, then-clerk of the court Nathan Hale Cogbill was instrumental in saving the records of the courthouse. It is believed that he carried most of the court's records to his grandfather's farm, located in Strawberry Hill off Beach Road. He stored them in the icehouse in "pine tags." He is seen here with his wife, Mary L. J. Winfree Cogbill. They were married in Prince George County on April 10, 1862. She died four years later, on March 26, 1866. (Courtesy Chesterfield Historical Society of Virginia.)

During the Civil War, Bermuda Hundred was the site of several battles. During the spring of 1864, Union general Butler and his troops were trying to destroy Confederate supply lines. The Confederates, led by P. G. T. Beauregard and his men, engaged the Union troops at several different locations in the area. Bermuda Hundred had been a small village but was a strategic point due to its proximity to the James River. Seen here is the Adams Express Office occupied by the Army of the James. (Courtesy Library of Congress.)

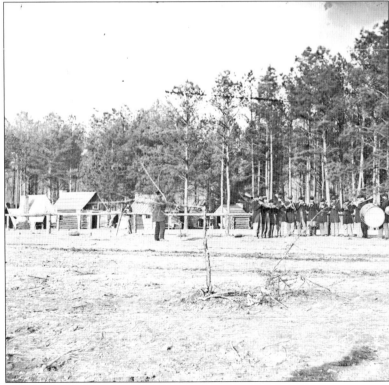

Chapin Farm was the site of General Butler's camp during the Civil War. His men took over the area to set up camp to defend their position and try to advance on Richmond. The strategy was unsuccessful. (Courtesy Library of Congress.)

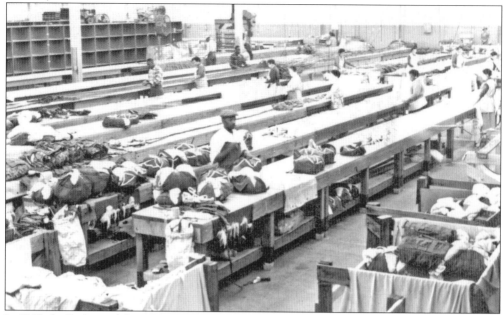

In 1949, the Richmond Quartermaster Depot, now the Defense Supply Center Richmond, handled the making and packing of parachutes. This is a picture of the assembly area where parachutes were packaged to be sent to the troops. The parachutes were also made at the depot. Parachutes are no longer sewn or folded here, as the mission—like the name of the center—has changed. (Courtesy Department of Defense.)

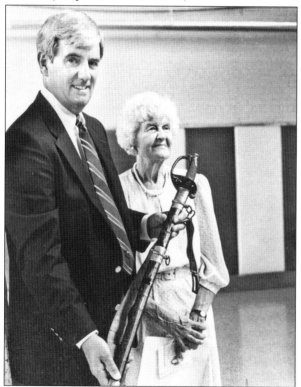

Geoffrey Hill Applegate, a former Chesterfield County supervisor from the Clover Hill District and the great-grandson of Gen. A. P. Hill, presented General Hill's sword to the Chesterfield Historical Society in 1989. His mother, Rosalie Pleasants Applegate, was in attendance. (Courtesy Chesterfield Historical Society of Virginia.)

The Defense Supply Center Richmond is located on land that was at one time owned by Thomas Sheffield in the early 17th century. His family perished in the infamous Massacre of 1622. During the Civil War, the Confederate army stationed in the area built Fort Darling at Drewry's Bluff. In 1887, the property was sold to James Bellwood. He was a very productive farmer, and his farm prospered. He even herded several elk. In 1941, the U.S. Army bought the land from his sons and agreed to care for the elk, which are still there to this day. The stately plantation the Bellwood family occupied became the Officers Club. During its first two decades, the mission of the Richmond Quartermaster Depot was to provide traditional logistics supplies for the U.S. Army. (Courtesy Department of Defense.)

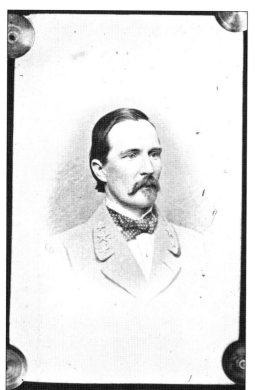

Gen. Henry Heth was one of four generals who served in the Confederate army who were born in Chesterfield County. He had attended the U.S. Military Academy before the war and had fought at Gettysburg with Gen. Edward Johnson. He and his men are actually credited with starting the Battle of Gettysburg because his men, many without shoes, were looking for a supply of Union shoes. After the war, he was a surveyor for the government in Washington, D.C., and is buried in Hollywood Cemetery in Richmond, Virginia. (Courtesy Library of Congress.)

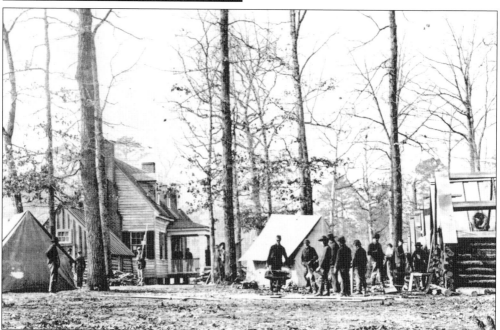

Gen. B. F. Butler and about 30,000 troops were sent to Bermuda Hundred to try to penetrate the Richmond Confederate stronghold. His camp, pictured here, was used for the troops. He used the Halfway House and Friend House, which were located on what was then known as Petersburg Pike. (Courtesy Library of Congress.)

Gen. A. V. Kautz, pictured here, was in charge of the Union cavalry in Virginia during the Civil War and was tasked with destroying tracks and other railway equipment to impede the advance of the Confederates. He brought up to 3,000 men on horseback to the Richmond and Danville Railroad station in Midlothian, then called Coalfield, in the middle of the night. They were able to destroy the tracks, office, water tank, and anything else they could find in the way of supplies. They continued their raids to other counties. These raids had a devastating effect on the Confederate war effort. (Courtesy Library of Congress.)

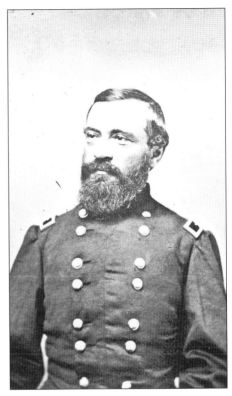

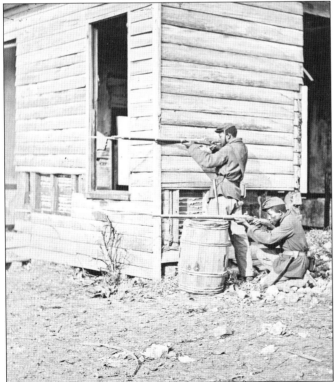

Soldiers pictured here defended a major federal naval route for their forces at Dutch Gap. General Butler gathered his troops to build a canal across the site. They transported 15,000 cubic yards of soil and prepared to blow up the rest. However, on New Year's Day 1865, their explosions caused the dirt to go back into the part they had dug and left them more vulnerable. Fortunately, with heavy rains, the river pushed through, and a 10-foot-wide area was opened for small boats to navigate. Ironically, in the early 17th century, when Sir Thomas Dale and his men began their settlement, they had dug out the gap to form a fortification against attack. (Courtesy Library of Congress.)

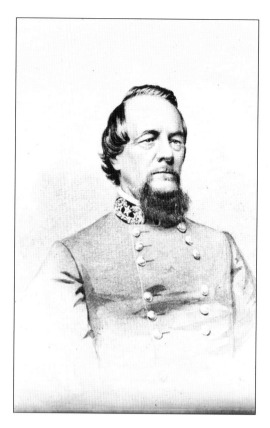

Gen. Edward Johnson was a native son of Chesterfield and a Confederate general who fought in several conflicts. He was captured twice and served his confinement at the Old Capitol Prison in Washington, D.C. He was released in 1865 and came back to Chesterfield. His family home, Salisbury, was still intact, and he lived there with his brother, Philip Johnson, until his death. He had been born at Salisbury in 1816 and died in the same home in 1873. (Courtesy Library of Congress.)

May 15, 1862 — Gen. Grant ordered Gen. Butler to advance on Richmond and Petersburg along the south bank of the James River. Though fewer than 2,000 Confederates defended nearby Petersburg, which lay only 2 miles away, Butler devoted his first day to digging trenches and only feebly probed the enemy defenses. The climax came at Drewry's Bluff. Butler decided to attack north toward Richmond but by then the Confederates, under the command of P.G.T. Beauregard, had gathered 20,000 reinforcements. The Federals were pushed back behind their trench line on the peninsula. Butler's army suffered 4,160 casualties, Beauregard's 2,506.

The Battle at Drewry's Bluff was commemorated in a first-day cover on the 125th anniversary of the battle. Shown on the cover is the Colorano "Silk" Cachet. It was a loss for the Union soldiers, and the casualties on both sides were 6,666 men.

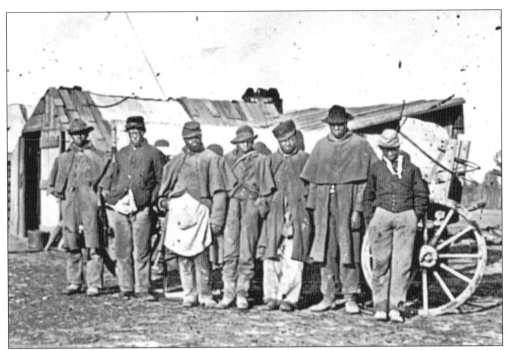

African American soldiers shown here were garrisoned at Drewry's Bluff. It included a fort that overlooked the James River as a fortification against troops trying to come up the river. This allowed the Confederate troops to guard against an attack of Richmond by water. (Courtesy Library of Congress.)

References to Point of Rocks are found in journals by Capt. John Smith in 1608 when he was traveling up the James River. During the Civil War, a Union signal tower, pictured, was assembled here to watch for ships and troops up and down the James River as well as signal ahead to the troops farther up the river. (Courtesy Library of Congress.)

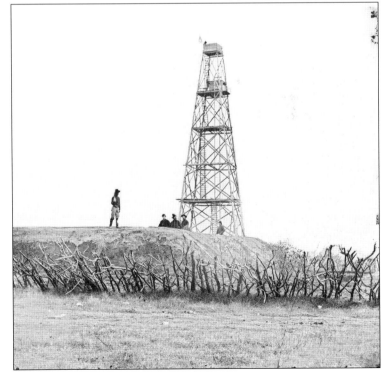

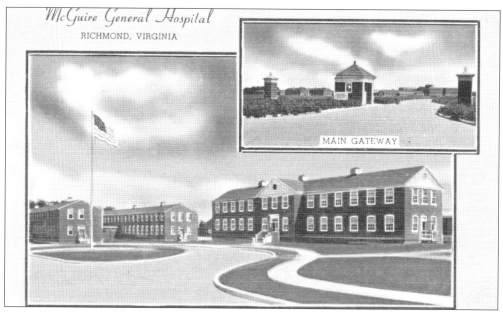

McGuire General Hospital
RICHMOND, VIRGINIA

MAIN GATEWAY

Located on the site of the Broad Rock Race Track, an army hospital was built to serve the needs of soldiers during World War II. The hospital was named after well-known Civil War surgeon Dr. Hunter Holmes McGuire. The campus included 70 brick and masonry buildings. Building began in August 1943, and it was ready to receive patients in July 1944. There were 1,784 beds; the overseas wounded from the war came here before being moved to hospitals near their homes. The site is now the Veterans Hospital for the area.

Dr. Hunter Holmes McGuire was a prominent physician and educator who lived in Richmond after having served in the Confederate army as a brigade surgeon. He was attached to Gen. Thomas "Stonewall" J. Jackson and was with him when Jackson was severely wounded and died in 1863. After the war, Dr. McGuire settled in Richmond as the chairman of surgery for the Medical College of Virginia. He and his wife, Mary Stuart McGuire, raised a family and had a summer house they frequented at 1706 Buford Road in Bon Air. The house was built in 1881 and is believed to be the first private cottage built in Bon Air. They used the home in the summers until 1889. McGuire was honored by the government when they named the army hospital in Chesterfield County after him.

Four

AGRICULTURE, MINING, AND MANUFACTURING

Located near the James River, the Bellona Foundry was constructed in 1810 in the northwest area of the county. The foundry made arms and ammunition for the U.S. Army. Sixteen years later, with land purchased from Willam and Polly Trabue, the government built an arsenal. It was made up of eight buildings, which were connected by a high brick wall. Ordnance troops and artillerymen were kept here. In 1856, it was sold to Dr. Junius Archer, who leased it to the Confederate army. Cannons were manufactured here for the war effort. (Courtesy Chesterfield Historical Society of Virginia.)

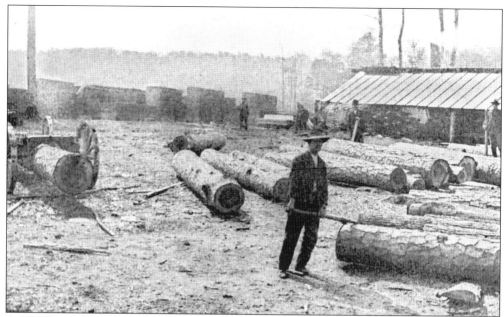

E. W. West was living in the Hallsboro area when he opened a sawmill to supply wood to the area. Sawmilling can be traced back to the 17th century as an industry in the county. (Courtesy Chesterfield Historical Society of Virginia.)

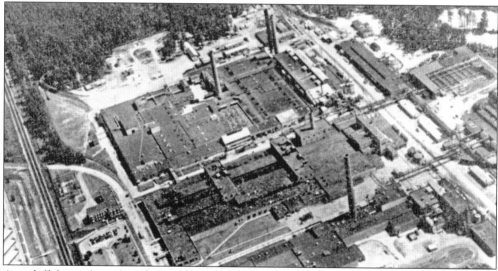

Ampthill, located on a low bluff north of Falling Creek, was the plantation home of Henry Cary I. He built the house in 1732. Several Carys owned the estate, as well as Robert Temple and W. O. Watkins. However, it was Hundson Cary who dismantled the home and moved it to the west end of Richmond. He then sold the property to E. I. DuPont de Nemours and Company in 1928. DuPont built rayon and cellophane plants on the site. There have been extensive additions, and the company set up rail and ship access to get the raw materials they needed and ship the products they manufactured. During World War II, the plant employed 4,100 people. In the 1950s, they began producing nylon, and in the 1960s, they produced a product that was used as a protective covering for space suits. The plant continues to produce and grow today. (Courtesy Chesterfield Historical Society of Virginia.)

There were a number of mining companies in the Midlothian area in the early to late 19th century. Once coal was discovered, mines sprang up all over the area. Some were run profitably, but some flourished for several years and then were taken over by the bigger mining companies. Miners used lamps and did not have the protective gear that miners have today. The mining companies found success, but more importantly, the other businesses in the area benefited from the people who moved here for the mines and their supply requirements. (Courtesy Chesterfield Historical Society of Virginia.)

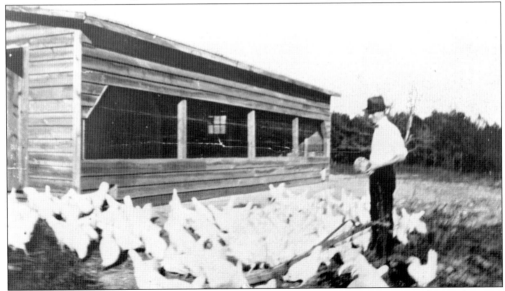

The county was made up of a diverse representation of farmers, mining companies, and manufacturers over the years. This photograph shows Guy M. Cheatham at his chicken farm in the 1920s. He started very small with a few chickens and grew to a large farm with a hatchery. He was the father of Lucille Cheatham Moseley. She was a founding member and past president of the Chesterfield Historical Society of Virginia. (Courtesy Chesterfield Historical Society of Virginia.)

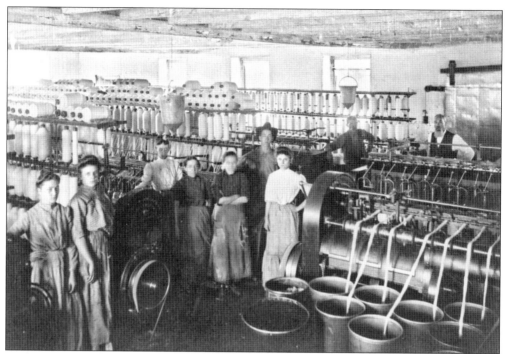

Pictured here is the spinning room of the Matoaca Mill. Laborers would work many hours on the machines for very little pay. (Courtesy Chesterfield Historical Society of Virginia.)

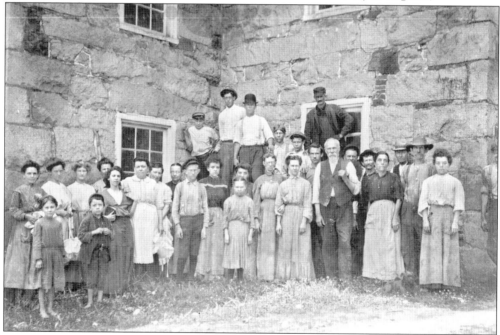

Matoaca workers are pictured in the mills of the area. This group picture was taken in June 1911. The small children on the left were only allowed to help a little, as they had to be 14 to actually work in the mills. This was a period when times were hard, and some people had to leave Matoaca to go to Richmond and Petersburg to find work. (Courtesy Library of Congress.)

The Black Heath Coal Pit was located between Bon Air and Midlothian. It was owned by the Heth family. In 1818, the *American Journal of Science* stated that the coal in the pit was 50 feet thick. In 1839, there was an explosion in the pit that took the lives of 54 men. It made the pit unworkable. Extensive work had to be done before the pit could be productive again. (Courtesy Chesterfield Historical Society.)

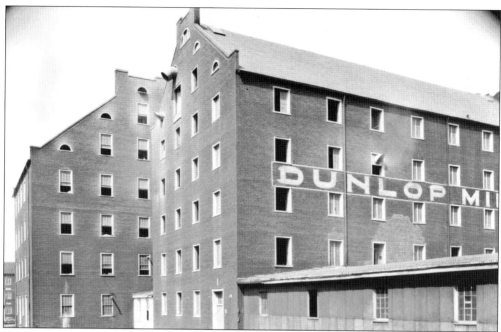

Manufacturing in Chesterfield made up a large part of the economy and a source of employment in the mid-19th century, as it does to this day. Dunlop Mills, at the corner of First and Hull Streets, contributed much to both. It was first established as Dunlop, Moncure, and Company by James Dunlop, H. W. Moncure, and Thomas W. McCance. The mill was a group of buildings that until 1866 was the largest mill of its kind in the country. A large manufacturer of flour, it was nationally known as a worldwide supplier of flour and was even referenced in the movie *Gone with the Wind*. (Courtesy Library of Congress.)

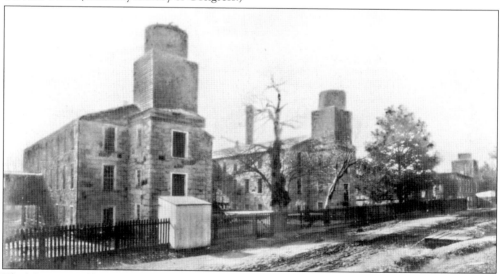

The Matoaca Mills, located in the southern part of the county, are shown here in 1905 when they were in full production. Manufacturing of cotton, hemp, and flax was done here and in other mills in the vicinity. In 1826, two large buildings had been constructed to house 4,000 spindles and 170 looms. The mills produced through the 1920s except for a period during the Civil War. (Courtesy Chesterfield Historical Society of Virginia.)

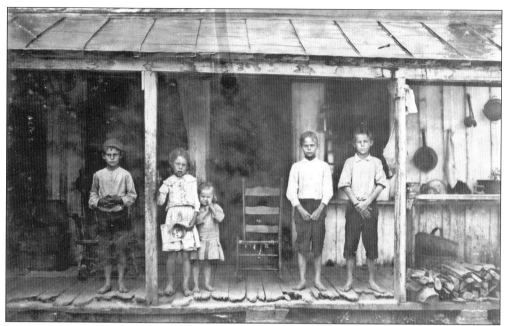

Children as young as 14 were working in the mills beside adults everyday. Lawrence Purdie (on the far right) had already been working in the mule room spinning for two years. Lawrence's brother has also been helping at the mill. The other children are too young to work. The father of the children, not shown here, was laid off and not working, which makes times tough. (Courtesy Library of Congress.)

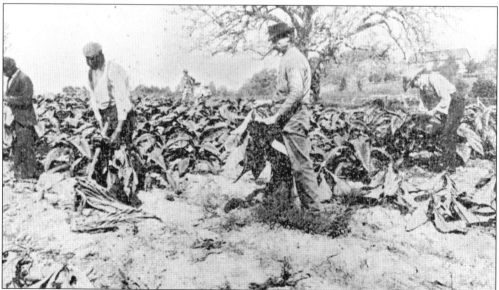

Tobacco was the cash crop for Virginia and the county for many years. From the beginning, when John Rolfe experimented with different seeds and leaves to find a productive and desirable blend of leaf, farmers had produced the much sought-after product. The climate of the region benefits tobacco farmers. Here at the W. F. Pell tobacco farm, located off Woodpecker Road, the leaves are being harvested and prepared for curing. (Courtesy Chesterfield Historical Society of Virginia.)

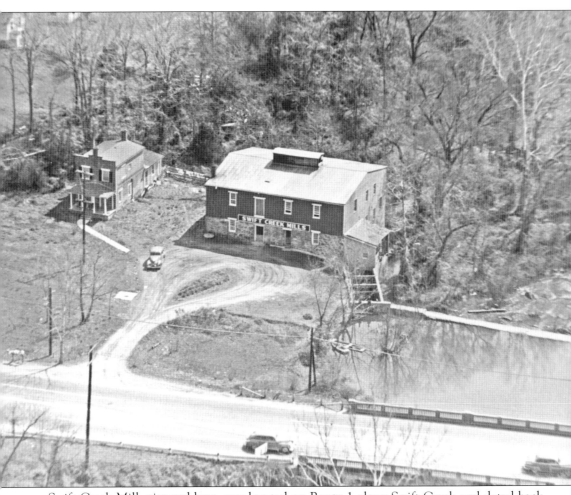

Swift Creek Mill, pictured here, was located on Route 1 along Swift Creek and dated back to the 1850s. However, there is evidence there were earlier mills on the property. Henry Randolph I came from England and in 1655 bought the land. In 1805, the Randolph descendants sold it to William Rowlett. Roughly 50 years later, Rowlett's heirs sold it to the Swift Creek Manufacturing Company. After the Civil War, it was a distillery for a time, making corn whiskey. It reverted back to being a mill until 1956. The mill was converted to a dinner theater in 1965 and has remained so ever since. (Courtesy Swift Creek Mill Theatre.)

Bellwood was a diversified farm not only using the land for planting but also raising elk. The traditional crops of tobacco, corn, cotton, and wheat were grown at the farm. They also had cows for a dairy operation. During the successful years the farm was in production, the Richmond Petersburg Electric Railway passed through the property and made frequent stops. The farm was sold to the federal government in the 1941 and became the Defense General Supply Center. The house became the Officers Club. (Courtesy Chesterfield Historical Society of Virginia.)

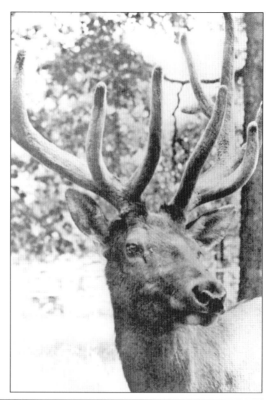

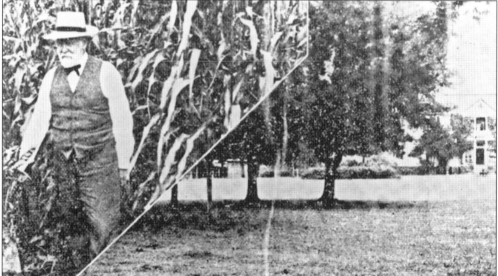

James Bellwood, pictured here, and his wife, Helen Turner Bellwood, lived at Bellwood, their farm located on the north side of Kingsland Creek near Route 1. The family owned the property from 1888 until it was sold to the government for a supply center. The house was originally built by Richard Gregory in 1797, and it was one of the earliest and largest homes in the county. During the Civil War, Fort Darling was built on the farm at Drewry's Bluff to fortify the James River. The corn stalks shown here were said to be seven feet tall, and the average production was 160 bushels per acre in 1910. (Courtesy Chesterfield Historical Society of Virginia.)

Grove Shaft Mines were built in the mid-19th century. The primary owner was the Wooldridge family. They had extensive mine properties in the area. They started the Midlothian Mining Company and were very productive for a number of years. In 1862, there was an explosion, and in 1882, another explosion occurred in the mine and 32 men died. The mine was 800 feet deep when it exploded. Later they were able to go in, drain the flooded shaft, and get it back to its former glory. This was short lived, since the Murphy Coal Company of West Virginia only kept it in operation for another four years. (Courtesy Chesterfield Historical Society of Virginia.)

Five

EDUCATION

Robious School was made up of one room. The photograph, taken in the spring of 1913, represents some of the oldest families in the area. The members of the class are, from left to right, (first row) Harry Heycock, Francis J. Pease, Herman Snead, Edgar Archer, and Middie Heath; (second row) Margaret Fleming, Anna Lee Payne, Margaret Heycock, Bessie Fleming, ? Heath, Medora Pease, Powell Heath, Waverly Payne, and Miss McGowan (teacher); (third row) Esten Cosby, Frederick Pease, Margarette Pease, Ada Fleming, Carlton Camack, Leslie Heath, and Bob Fleming. Miss McGowan died that summer after contracting typhoid fever at a picnic in Chesterfield. (Courtesy Chesterfield Historical Society of Virginia.)

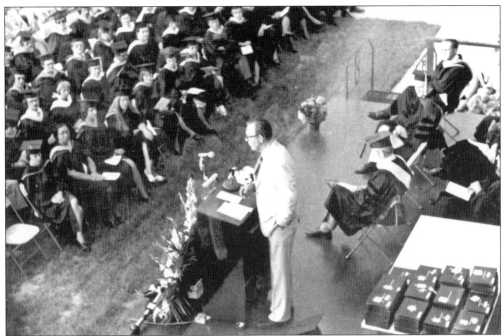

In 1975, the graduating class of John Tyler Community College is shown listening to the commencement speaker, Alden Aaroe. Aaroe was a local radio personality and familiar voice on WRVA radio station in the 1970s with his friend "Millard the Mallard." The college has seen many changes since that time, with the number of students growing from the first year, 1967, to the present. (Courtesy John Tyler Community College.)

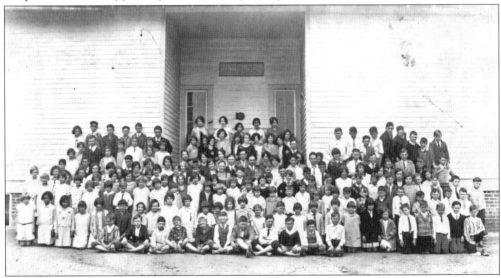

This is a photograph of students and faculty from Grange Hall in the Skinquarter area. Taken in 1926, there are several people identified in the picture. The teacher, Nannie Leigh Viar, married Jennings K. Deane. The principal, located in the center wearing glasses, is James I. Wood. Also pictured are G. Levis Crump, former school board chairman; Mrs. Frances Crump (with long curls); Sherman Green Crump; Mrs. Earle Goode; Joyce Crump; and James Willard. (Courtesy Chesterfield Historical Society of Virginia.)

Pictured here are the beginnings of John Tyler Community College. With a generous donation of land from Harold T. Goyne Sr., who was chairman of the county board of supervisors, the school broke ground on June 12, 1966. It was established by the Commonwealth of Virginia to offer classes to people of the region in the areas of technical education as well as adult education and the first two years of a college education that could be transferred to four-year institutions. The road at the bottom of this picture is Jefferson Davis Highway (Route 1). The first three buildings were Goyne Hall, named after the benefactor of the land; Godwin Hall, named after Gov. Mills Godwin, who championed the establishment of the community college system; and Bird Hall, named for Sen. L. C. Bird, who helped obtain the funding from the state to construct the buildings. Classes began on October 2, 1967. In 1973, as the school expanded its programs and more students arrived, Moyer Hall was built as a learning resource building housing the library and other administrative offices and classrooms. Moyer was named for George Moyer, who had served on the first college board and contributed to its growth. The school branched out into the community with classes offered in the 1980s at Fort Lee and a Midlothian Outreach Office. By 1987, the college was serving 11,172 students over the course of the year. On December 12, 1988, Bird Hall was damaged by a fire that destroyed much of the building. However the school survived and continues to grow, with a second campus in Midlothian and the addition of buildings on the Chester campus. (Courtesy John Tyler Community College.)

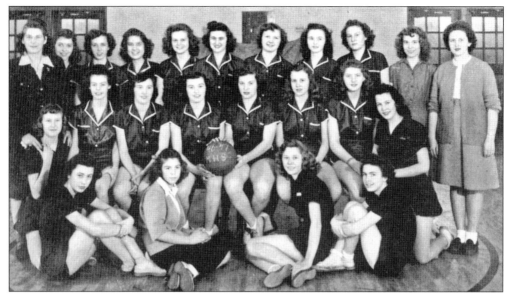

Manchester High School in 1947 had an extremely good Manchester girls' basketball squad, winning every game. Some of the teams they played were Varina, Highland Springs, Glen Allen, and Midlothian. Shown here are, from left to right, (first row) Frances Taylor, Phyllis Jolly (assistant), Ann Hagood, and Margaret Simpson; (second row) Doris Collins, Betty Jan Maxwell, Margaret Winfree, Elizabeth Winfree (cocaptain), Ann Cox (cocaptain), Irene Jones, Ann Chaffin, and Ardith Evans; (third row) Ruby Adams (coach), Joan McDaniel, Virginia Johnson, Doris Wigglesworth, Sarah Rowlett, Mary Ann Horner, Edna Claiborne, Kathleen Hagood, Cecile Orcutt, Ruth Reams, and Christine Balsley (manager). (Courtesy Chesterfield Historical Society of Virginia.)

Hickory Hill High School drum majorettes performed at various school events. In 1949, Hickory Hill and D. Webster Davis High School merged to form Carver High School for black students. (Courtesy Chesterfield Historical Society of Virginia.)

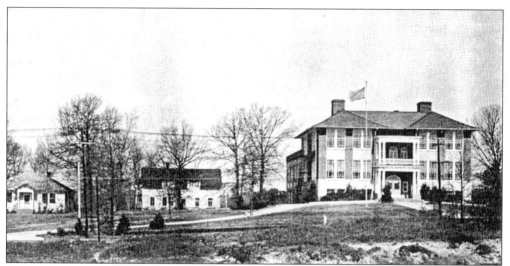

Chester High School, pictured on the right, was the second location, as the first building on Percival Street was outgrown when they added a third year of high school. This building on Richmond Street was originally the Shirley Seminary, owned by George Robertson. In 1926, there were two additions to the school. A Manual Training Building and a Home Economics Building were completed to give more room for the growing student population. (Courtesy Chesterfield Historical Society of Virginia.)

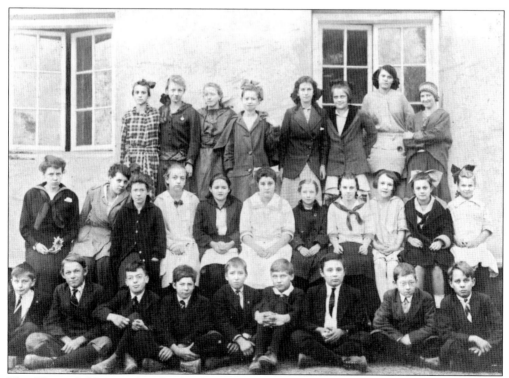

The Chesterfield Agricultural School was established in the late 19th century for the needs of children in the area. Seen here is the sixth-grade class of the school in the early 20th century. (Courtesy Chesterfield Historical Society of Virginia.)

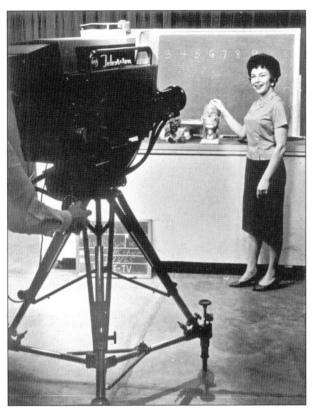

In 1963, a television engineer named Benjamin William "Bill" Spiller working in Louisiana was recruited to come to Richmond and serve as the general manager for WCVE-TV (Channel 23). He helped to build the new station, and they began transmitting September 14, 1964, at their studios near Huguenot Park off Robious Road. Some of the early patrons included Thomas Boushall, E. Claiborne Robins Sr., and Mary Ann Franklin. Much of its purpose was to serve the community in an educational capacity as well as public service. Here we see Hope Mitchell teaching a science class for students in the late 1960s. (Courtesy Commonwealth Broadcasting.)

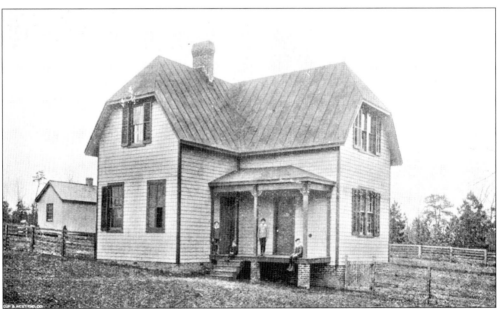

The first public school in Bon Air was located in the western part of the village near the Kilbourne Plantation. In 1883, Col. A. S. Buford built a better structure at Buford Road and Larkspur Lane. Public schools did not have the best facilities. However there were a number of private schools that functioned in the area. (Courtesy Bon Air Public Library.)

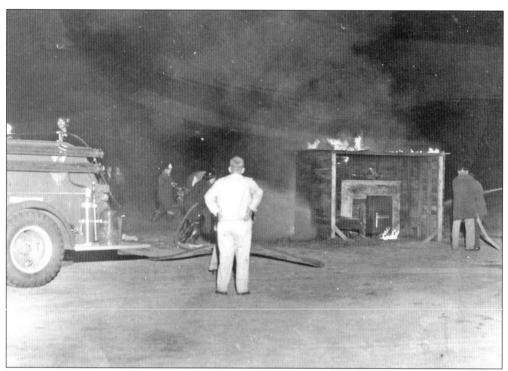

On October 9, 1956, there was an extensive fire at Ettrick School. Shown here is the Matoaca-Ettrick Fire Department fighting the blaze. (Courtesy Chesterfield Historical Society of Virginia.)

Students from a local school are seen here in the 1950s in a county-wide performance celebrating the arts and music. (Courtesy Chesterfield Historical Society of Virginia.)

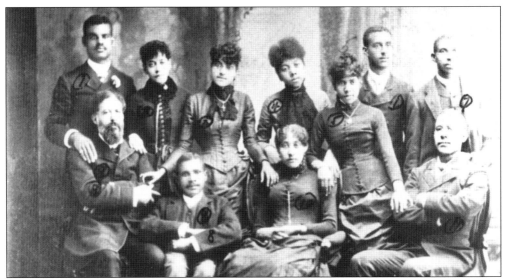

Virginia State University, located in the Ettrick area of the county, was originally created as the Virginia Normal and Collegiate Institute for the education of black students. It had been established with the efforts of William Mahone. He was a former Confederate soldier who felt strongly about establishing public schools for the education of former slaves and blacks. The school would be run in the beginning by John M. Langston. Included here is the first graduating class. Pictured are, from left to right, (first row) John M. Langston (president), Robert Green, Mrs. Ida R. Harris, and Prof. James Colson Jr.; (second row) James Shields, Lucretia Campbell, Susie Douglas, Fannie Walker, Carrie Bragg, Willie Davis, and Jerry Lucas. (Courtesy Chesterfield Historical Society of Virginia.)

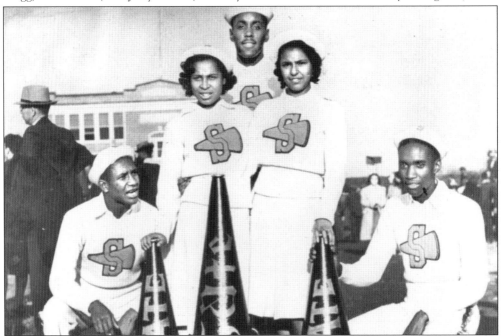

Pictured here are members of the 1939 cheerleading squad for Virginia State College, now Virginia State University. They are preparing for a big game. (Courtesy Chesterfield Historical Society of Virginia.)

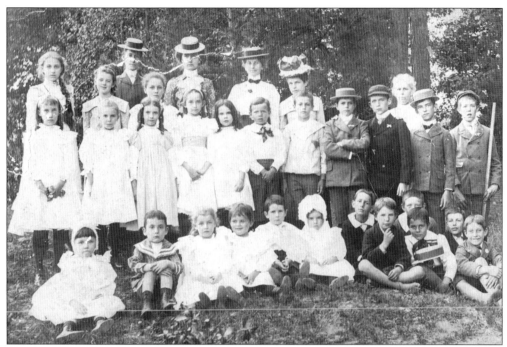

An early school group from Bon Air is on an outing in the spring. Several private schools were set up in Bon Air. Some were just for boys or just for girls. (Courtesy Bon Air Public Library.)

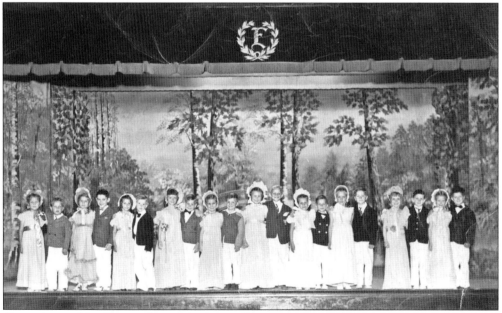

Shown here is Mrs. Young's first-grade class performing at the Ettrick Elementary School, located in southern Chesterfield. The school had seven grades, as there was no middle school in the area at the time. The only person identified in the picture is Edward Wayne Perkinson, who was born in 1941. He is 10th from the left. He was six years old at the time. When he was in the third grade, he drowned while attending a church picnic at Pocahontas State Park. (Courtesy Mary Perkinson Chalkley.)

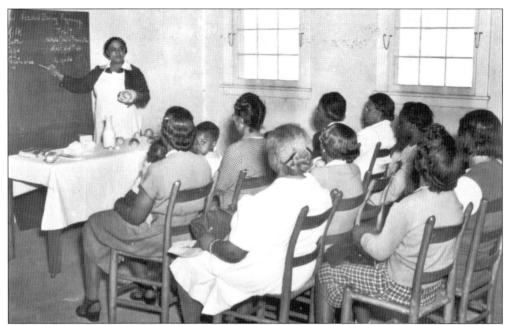

Mrs. Bertha Britton was the first black public health nurse in the county. She worked tirelessly for over 26 years in that capacity. Some of her responsibilities included assisting the doctor during clinics and holding training classes in nutrition and other health-related areas. She would also give vaccinations to children before they attended school. (Courtesy Chesterfield Historical Society of Virginia.)

Mrs. Bertha Britton received an award in 1984 from the Medical College of Virginia Alumni Association in honor of her many years of service to the community. She had served Chesterfield in the capacity of a public health nurse for many years. (Courtesy Chesterfield Historical Society of Virginia.)

Bobby socks and saddle oxfords were the order of the day in 1955 for the varsity cheerleading squad of Midlothian High School. The school was originally built in 1924 and additions were added in the 1940s, 1950s, and 1960s. In 1970, the old building was torn down and a new building was completed. The members of the squad were, from left to right, Carolyn Withrow, Jan McCann (cocaptain), Floy Lee Gills, Anne Arendall, Teddie Noyes (cocaptain), Matt McCeney, Grace Arendall, Nancy Sue Birch, Martha Gaddis, and Priscilla Staples. The team's sponsor was Alice Newland. (Courtesy Chesterfield Historical Society of Virginia.)

The 1970 cheerleading squad of Midlothian High School changed from the girls of 1955. The saddle oxfords gave way to tennis shoes, and skirts went from dark to light and were considerably shorter. But the things they had in common were the "M" emblazoned on their sweaters and their enthusiasm. The varsity cheerleaders pictured included Brenda Webb (cocaptain), Ann Thacker, Onna Abrams, Barbara Reinhard, Vicki Tuttle, Linda Steinbach, Mary Sharp, Susan Stinnette, Jan Trimmer, Markie Wray, Gayle Esbenshade, and Mindy Phipps (captain). (Courtesy Chesterfield Historical Society of Virginia.)

Students at the Midlothian High School of 1965, located on Midlothian Turnpike, were very proud of their football team that year. The Midlothian Trojans were successful against such teams as Varina, Lee Davis, Meadowbrook, and Henrico. They finished that year with a 7-2-1 record. The coach was Jim McGinnis. The team was, from left to right, (first row) F. Isemann, J. Watkins, R. Hill, T. Carroll, C. Douglas, W. Harris, C. Rock, and B. Crump; (second row) B. Marks, R. Lester, M. Smith, M. Carroll, G. Henshaw, M. Watkins, J. Hagood, and D. Douglas; (third row) G. Rountree, L. Stafford, L. Marks, W. Isbell, D. Brunner, D. Short, D. Cundiff, and H. Smith; (fourth row) C. Newcomb, R. Welton, J. Cosby, R. Hoke, B. Jones, E. Whitlock, and A. Whitlock; (fifth row) Coach Keadle, Coach Wagner, and Coach Jim McGinnis. (Courtesy Dale Paige Talley.)

Six

HOUSES OF WORSHIP

Many people came to the New World to seek different freedoms. Religious freedom was one of those, and ironically there was still persecution that some groups endured in the late 18th century. Several men who came to Chesterfield to preach did not have the required licenses. Seven of them were put in the Chesterfield jail between 1770 and 1774. John Tanner, David Tinsley, William Webber, Joseph Anthony, Augustine Eastin, Jeremiah Walker, and John Weatherford were called the Apostles of Religious Liberty. Even while imprisoned, some of the men preached from their cells when crowds of people came to the jail to hear their sermons. In 1925, the churches of the Middle District Baptist Association erected a granite monument to these men and placed it at the courthouse where they were held. (Courtesy Chesterfield Historical Society of Virginia.)

In the beginning of the Methodist faith in Chesterfield County, meetings were held in residents' homes. The Wood's United Methodist Church, on Hickory Road, was established in a church abandoned by an Anglican group that originally served the needs of parishioners near Ettrick. Timbers dating back to 1707 show how old the original church was. The church is said to be named after Abraham Wood, an English settler serving as a colonial representative in 1644. The church has gone through several renovations, first in the early 1830s and again in 1877. In 1890, it was torn down and replaced in the same spot. It also has one of the earliest church cemeteries in the county (before 1860). The present church began as a single-room building before 1949. In the 1950s and 1960s, a second wing and an educational building were added. The church thrives today with a strong congregation. (Courtesy Mary Perkinson Chalkley.)

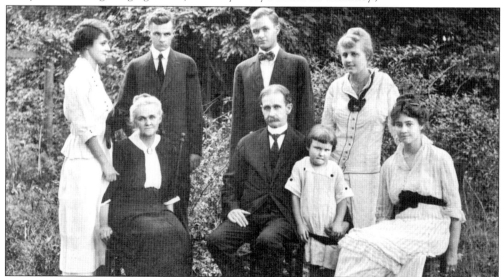

Dr. Edwin Brown McCluer became pastor of the Bon Air Presbyterian Church in 1905. He was the editor of the *Presbyterian Publication of the South* before coming to Bon Air. He is seen here with his family. They are, from left to right, (first row) Mrs. Cora Bates McCluer, Dr. McCluer, Babs McCluer, and Betsy McCluer; (second row) Margaret McCluer, Edwin McCluer, Bates McCluer, and Nell McCluer. Dr. McCluer's son Edwin, known as Ted, was one of the most decorated soldiers in World War I. (Courtesy Bon Air Public Library.)

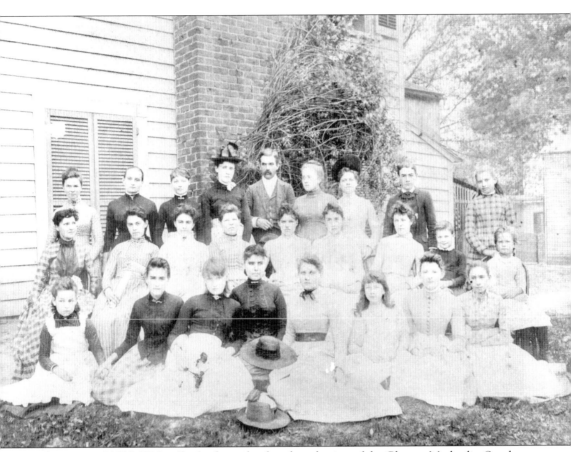

In the spring of 1888, Walter Perdue hosted a church gathering of the Chester Methodist Sunday school at his home, Warfield. The parishioners are shown on the grounds next to the house. The only person identified in the picture is Walter Perdue, in the middle of the back row. (Courtesy Chesterfield Historical Society of Virginia.)

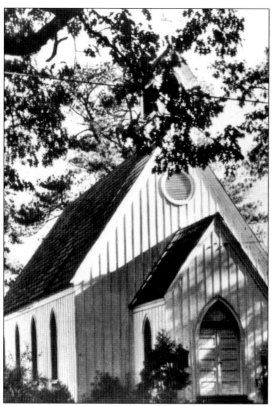

The first services for Episcopalians that lived in the Chester area were held at the Chester Hotel. It was not until the 1880s that parishioners had their own church. The new church, St. John's Episcopal Church, was located on Richmond Street in Chester. It was completed in December 1880 at a cost of $1,500. The congregation grew, and in the 1950s, several additions were built. In 1975, the church and additions burned down. The church was rebuilt and completed in 1978. (Courtesy Chesterfield Historical Society of Virginia.)

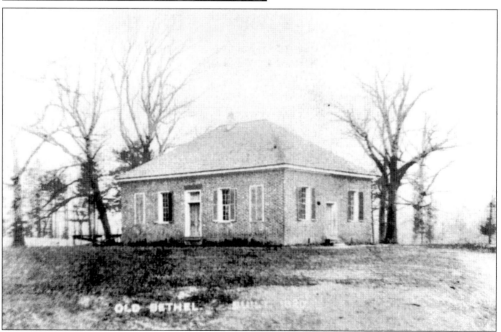

The Bethel Baptist Church was established in 1799 from members of the existing Spring Creek Church. This was one of two previous meeting places before the permanent location on Huguenot Springs Road. (Courtesy Chesterfield Historical Society of Virginia.)

Trinity Church was originally the Salem Church when it was built in 1727. It later became Sapponey Church, and finally, when it was moved, it became Trinity Church. The Reverend A. B. Tizzard was pastor from 1847 to 1897. (Courtesy Chesterfield Historical Society of Virginia.)

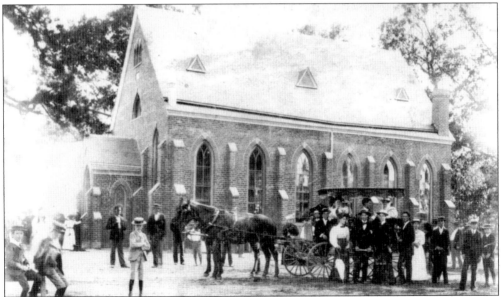

The Bethel Baptist Church was built in 1894. Once begun, the church was built very quickly. It was started in April and completed August 7 of the same year. The church cost $3,223.60, and the parishioners were able to pay for it by the time the church was dedicated. Some of the members pictured here are James P. Baker, Nan Taylor, Tony Thurman, J. A. Spears, Bob Beatlie, Lula Taylor, Jeter Atkinson, Frank Meade, Eddie Baker, Cassie Taylor, John W. Justis, and B. T. Watkins. (Courtesy Chesterfield Historical Society of Virginia.)

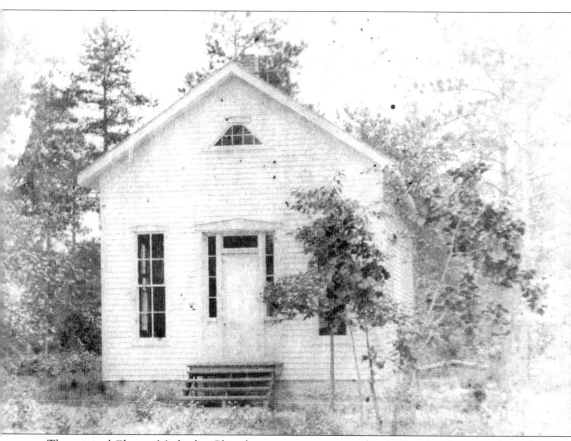

The original Chester Methodist Church property was acquired in 1873. After 54 years of use, the building was sold to O. K. Marquis, and the congregation moved to a new building on Percival Street. The old building was remodeled and became an indoor basketball court. It was the first of its kind in Chester. Local schools and the community used the facility from 1927 until it was converted into a private residence. (Courtesy Chesterfield Historical Society of Virginia.)

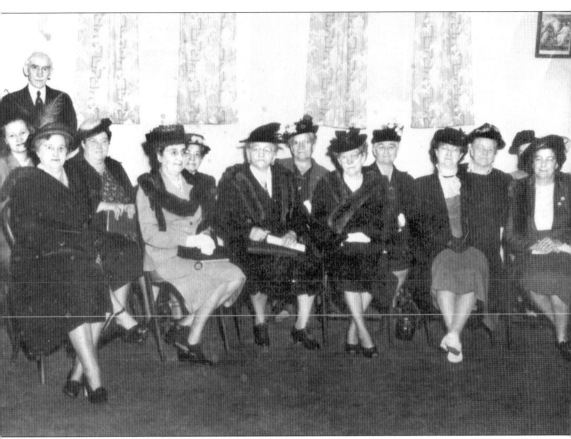

The Chester ladies Bible class at the church was taught by the clerk of the court, Mr. Walter N. Perdue. The meetings were attended by the following women, from left to right: (first row) Mrs. J. E. Blankenship, Mrs. H. T. Goyne Sr., Mrs. Mamie Sanders, Mrs. ? Dance, Mrs. ? Mumford, and Mrs. C. E. Curtis Sr.; (second row) Mrs. Charlotte Ruffin, Mrs. Thelma Johnson, Mrs. J. R. Moody, Mrs. ? Wilmouth, Mrs. L. S. Grant, Mrs. P. M. Tyler, and unidentified. (Courtesy Chesterfield Historical Society of Virginia.)

The first Baptist church in the county was established in 1773. After that, churches sprang up all over the county to serve the parishioners. Skinquarter Baptist Church was established in 1778. The Skinquarter Baptist Church is pictured in the top right corner. The old parish house is located in the middle. The original church had been built with two entrances. One door was for men and boys and the other for women and young children. As times changed, the church was remodeled in 1952. The church was located next to Richard Belcher's land patent of 1754, in the upper right corner. Sims House, obstructed by trees, is located in the lower right corner. It was built by John Spears Sims, who was buried behind the house at his death in 1897. His son Joseph Benjamin Sims was the proprietor of a general store attached to the house, which was later moved to Moseley. (Chesterfield County Historical Society of Virginia.)

The First Baptist Church at Centralia started out as the Salem African Church. The congregation had attended Salem Baptist but wanted their own church. In 1867, the Reverend Lewis Branch was the first pastor. It was the largest standing church of its type in the county. Pictured here is the senior choir for the church in the late 1950s. The church supported several choirs to serve the community. Mrs. Nellie Street was president and Mrs. Eugenia S. Miller was director. (Courtesy Chesterfield Historical Society of Virginia.)

Seven

ORGANIZATIONS

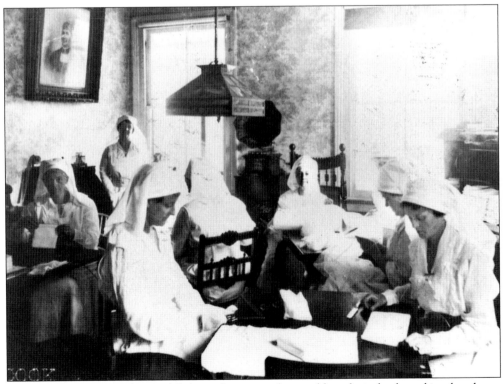

The Red Cross was made up of dedicated women who would work tirelessly making bandages, helping soldiers and their families, and nursing the sick and injured during World War I. This photograph shows members of the Bon Air Red Cross rolling bandages in the home of the Hazen family. (Courtesy Chesterfield Historical Society of Virginia.)

The Chester Masonic Lodge No. 94 had its first meeting hall located at the corner of Gill Street and the Atlantic Coastline Railway tracks. It was built in 1850 by James L. Snead and rented to the organization for $3 per month. The group later moved to a larger facility. (Courtesy Chesterfield Historical Society of Virginia.)

The Centralia Woman's Club picture was taken to appear on the cover of the booklet commemorating the names of chapter hostesses. The club was located near Salem Baptist Church at Centralia and Salem Roads. Hostesses for 1937 were Mrs. H. C. Cline, Mrs. James Cowan, Mrs. W. A. Winfree, Mrs. L. G. Ogden, Ulai Mangum, Mrs. Herbert Cogbill, Lena Warwick, Mrs. O. B. Gates, Helen Ward, Mrs. John Wray, and Mrs. E. A. Brown. (Courtesy Chesterfield Historical Society of Virginia.)

In the early 1950s, the Woodpecker Lodge Grange, located on Woodpecker Road, held a talent show for the March of Dimes. Pictured here are, from left to right, (first row) Annie Perkinson, Florence Clayton, Katherine Hogwood, and Hattie Burton; (second row) Daniel B. Perkinson, Willie Dance, Howard Clayton, Pete Vaughan, and John Burton.(Courtesy Mary Perkinson Chalkley.)

The Chesterfield Historical Society of Virginia was begun in September 1981 by a dedicated group of county residents and had 253 charter members. The society has dedicated itself to the preservation of history and education of the county's past. Pictured here are the first four presidents of the society. They are, from left to right, Judge Ernest P. Gates Sr. (served 1981–1983), Lucille Cheatham Moseley (served 1983–1985), Mary Arline McGuire (served 1985–1987), and W. Baxter Perkinson Sr. (served 1987–1989). (Courtesy Chesterfield Historical Society of Virginia.)

Capt. W. W. Baker was born in 1844 to a family having five generations in Chesterfield and Powhatan Counties. He fought in the Civil War as a member of Capt. John Yates Beall's rebel forces. When he returned to the county after the war, he held a number of offices representing Chesterfield. He was appointed by Gov. Gilbert C. Walker in 1866 to be justice of the peace in the county. He was supervisor for the Midlothian District and also held the position of school trustee. Later he ran and won a seat in the Virginia House of Delegates in 1883. He was affiliated with the Richmond Medical College for many years and served as a trustee. Camp Baker was named in his honor in 1929. (Courtesy Chesterfield Historical Society of Virginia.)

Lila Spivey was the county's first health nurse. One of her charges was to provide information to the community on disease prevention and how to improve health. However it was her dedication to helping establish Camp W. W. Baker that she will be remembered for. She wanted to create the camp to help undernourished children come to a place where they could have the opportunity to get exercise, eat nutritional food, and help improve their lives. She continued for many years to work in the county. (Courtesy Chesterfield Historical Society of Virginia.)

In the 1930s, many Americans were destitute because of the Depression. Children were some of the biggest victims of this solemn time. A nurse in Chesterfield, Lila Spivey, wanted to do something about the children's plight. Spivey saw firsthand the toll taken on the children of the area. She helped establish a camp for needy children to help bring them back to health. She chose to dedicate the camp to Capt. W. W. Baker in honor of his service to the state of Virginia. Captain Baker promoted health issues and reorganized the Virginia State Health Board. The girls at camp in the early 1930s gather around the flagpole to start the day. The camp was completed in July 1929 and opened July 23, 1929. In 1956, the Richmond Association of Retarded Children rented the camp and continues to use it today. (Courtesy Chesterfield Historical Society of Virginia.)

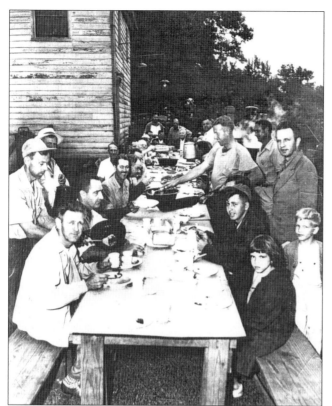

The Chesterfield County Farmers Club was an organization where farmers could get together and discuss the events of the day. Here, in 1949, the group is sitting down to eat stew they made. Walter Fred Young is extending his plate for seconds. (Courtesy Chesterfield Historical Society of Virginia.)

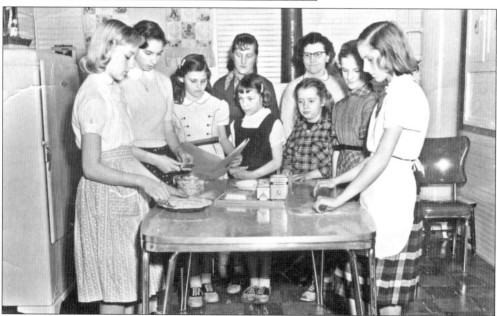

The Hickory Road Girls 4-H Club is shown working on a cooking project in the early 1950s. Pictured from left to right are Sallie Howlett, Mary Perkinson, Carol Spain, Doris Jackson (song leader), Jeannie Perkinson, Emma McFarland, Annie Perkinson (4-H leader), Carol Schenck (president), and Sue Jackson (treasurer). (Courtesy Mary Perkinson Chalkley.)

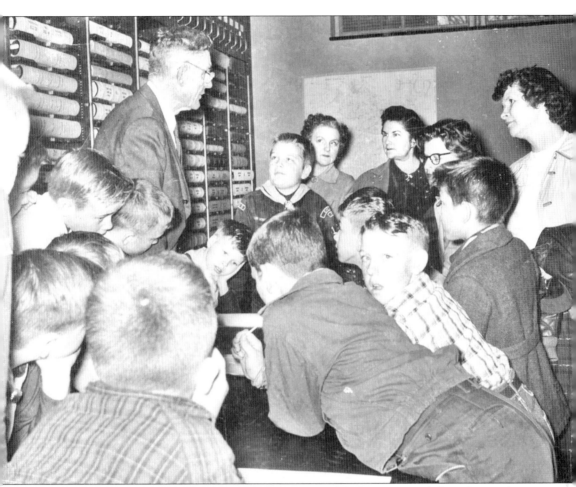

Sheriff O. B. Gates is shown in April 1960 showing a Cub Scout troop and their den mothers the county clerk's office. Sheriff Gates served first as a deputy in the county and then as sheriff for 43 years, from 1925 to 1967. Sheriff Gates was married to Ida May Heath Gates and lived to be 102. Toward the end of his life, he lived with his dog, Fine, in the Lucy Corr Nursing Home. He died in 1988. He and Ida Gates were the parents of Judge Ernest Gates, another prominent Chesterfield official. (Courtesy Chesterfield Historical Society of Virginia.)

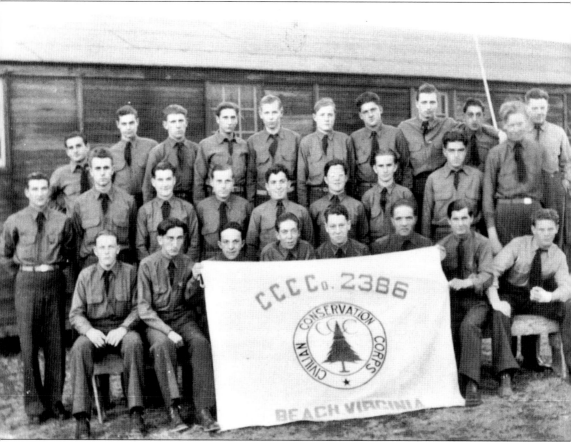

In the 1930s, there was much work to be done to create jobs and improve people's quality of living. Franklin D. Roosevelt wanted to make more jobs available. On July 24, 1935, the Civilian Conservation Corps Camp Project was organized and was completely set up four months later. The major assignment of the group was to build large and small dams at Swift Creek. They were also given the task to construct the buildings of the state park that was known as Swift Creek Park, later Pocahontas State Park. The name assigned to Chesterfield was Camp SP-24. The commanding officer for the camp was Charles W. Kiser Jr., first lieutenant of field artillery (retired). Once the work was done around the country, the program was abolished by an act of Congress in 1942 after the war started. (Courtesy Chesterfield Historical Society of Virginia.)

Eight

SPORTS, ENTERTAINMENT, AND EVENTS

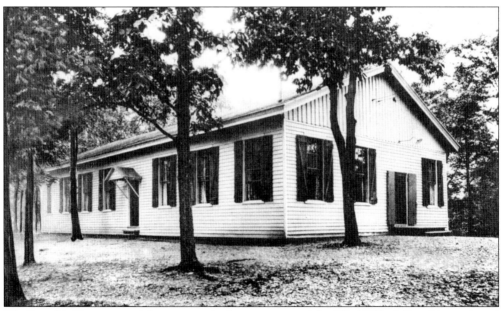

The Bon Air Center served the community for many years. After World War I, Bon Air continued to be a closely knit group, and in 1923, the Bon Air Hotel dance pavilion was enclosed and converted into the center. It was established to "promote and foster the literary, educational and physical interests and welfare of its members." In 1947, the Bon Air Community Association was established. This building burned down in 1959. (Courtesy Bon Air Public Library.)

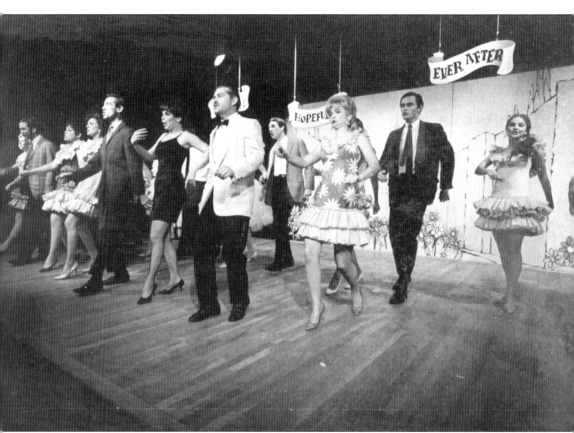

For many years, the Swift Creek Mill served the community as a mill. However, in the mid-1950s, two local theater enthusiasts began talking about establishing a community theater. The two men, Wamer (Buddy) Callahan and Dr. Louis Rubin, saw their dream become a reality when the Swift Creek Mill Playhouse, as it was known, opened on December 2, 1965, with a production of *Carnival*. The building had been renovated to add a kitchen, restrooms, and dressing rooms for the actors. Shown here is a production number from the musical *Sweet Charity*, which ran from June 6 through August 31, 1968. Directed by Wamer J. Callahan, the two leads were played by Jackie Gann as Charity and Macklin Columber as Oscar. Supporting roles were played by Edie Williams as Nickie, Barbara Hobgood as Helene, and Ray Schreiner as Villorio. (Courtesy Swift Creek Mill Theatre.)

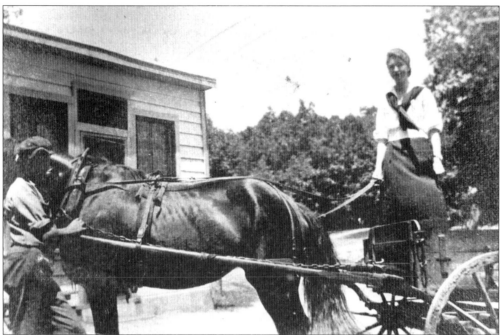

In 1920, horse-drawn wagons were still a common site around Chester for transportation. In this photograph, Mary Truby, who worked at Ruffin and Graves, is in front of Alexander's Barber Shop, which was the first one in Chester. (Courtesy Chesterfield Historical Society of Virginia.)

As the county grew and more businesses moved into the area, government officials realized an airport could be beneficial. They began to take the steps to establish an airport off Ironbridge Road near the county government offices. In 1970, plans were made to build the necessary buildings and runways. However, there was a private group calling themselves Citizens' Airport Committee that tried to block the airport. They tried repeatedly to stop the airport, but in the end they were not successful. Melvin W. Burnett, the executive secretary to the board of supervisors from 1949 to 1974, was instrumental in getting the airport completed. In 1988, when renovations were done to the existing terminal, it was renamed the Melvin W. Burnett Terminal in honor of his tireless effort to bring an airport to the county. (Courtesy Chesterfield Historical Society of Virginia.)

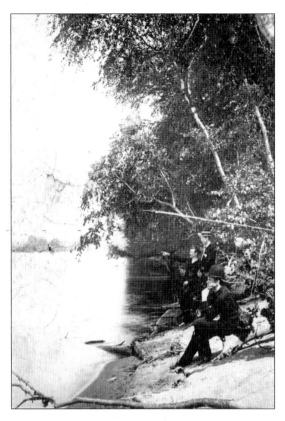

Fishing was abundant in the lakes and rivers around the county. Bosher's Dam was built in 1795 and was one of the state's multipurpose dams for storage and power. Here on Bosher's Dam, some men are taking it easy on a pleasant afternoon, catching fish and catching up on the news of the day. Dr. Charles Morse Hazen is shown in the foreground. Dr. Hazen, born in 1865, attended medical school in Richmond, Virginia, and practiced medicine in Richmond and Chesterfield County. Because of his interest in physiology, it is believed that he built one of the first x-ray machines here. He died in 1953. (Courtesy Bon Air Public Library.)

Moore's Lake was an inviting spot for families to go to cool off from the summer heat. Picnics and group outings made the lake popular for many years. The lake was located half a mile north of Route 10 on U.S. Route 1. (Courtesy Chesterfield Historical Society of Virginia.)

Violet Bank was the site of many cultural and social events as the owner, Mrs. A. V. Pierrepont, was known for her entertaining venues. Here is a gathering of women for an art class held on a Sunday in May 1932. (Courtesy Chesterfield Historical Society of Virginia.)

Women's high school sports have always been an important part of school athletic programs in the county. In the spring of 1965, the Midlothian High School girls' softball team was full of enthusiasm. The girls received new uniforms that year and had a 16-game season. The most valuable player was Ann Ayscue. The coach was Mrs. Ashcraft. The team was, from left to right, (first row) B. Grady, S. Wooten, E. Salle, R. Totty, V. Brown, M. Vincent, and B. Salle; (second row) Coach Ashcraft, B. Burton, C. Thompson, A. Ayscue, L. Hall, R. Grant, K. Grady, and D. Gayle. (Courtesy Dale Page Talley.)

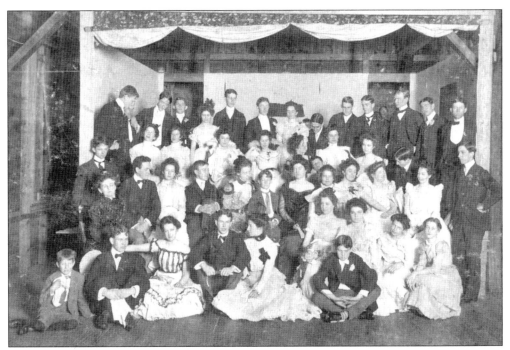

The Bon Air Pavilion was the site of many dances, parties, and social functions. This photograph is of the opening of the Bon Air Cotillion Club on April 27, 1900. (Courtesy Bon Air Public Library.)

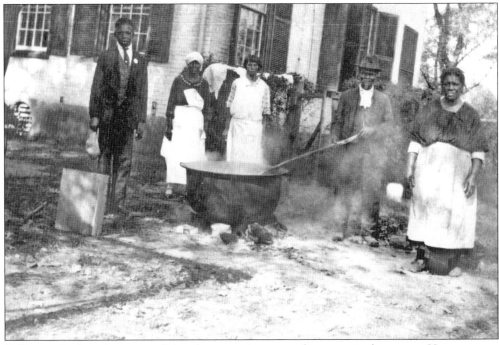

Selling cooked goods was a traditional way to raise money for causes in the county. Here servants at Magnolia Grange cook stew to sell at the county fair to raise money for the Camp Baker Fund. The camp would later be built to allow underprivileged children to spend time in the fresh air and eat nutritional meals. (Courtesy Chesterfield Historical Society of Virginia.)

The Public Broadcasting Station in Virginia, located off Robious Road, has been broadcasting community stories, locally produced human interest stories, and other entertainment features since it began in 1964. One of the many services they provided in the 1960s and 1970s was to cover the political scene and educational symposiums by hosting debates and on-air presentations, as seen in the photograph. (Courtesy Commonwealth Public Broadcasting.)

Thomas Callen Woodson worked as a telegraph operator for the Norfolk and Western Railroad in Crewe, Virginia. He married Bettie Haskins Winfree in 1907, and they moved to Crewe in Nottoway County. Here he is seen with a bicycle that was used frequently for entertainment and for transportation. (Courtesy Bettie Woodson Weaver.)

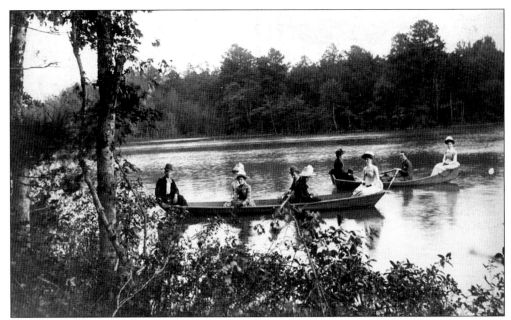

Jahnke Lake was a central point of the social life of the Bon Air community in the late 19th and early 20th centuries. Groups of picnickers, swimmers, and people in canoes frequented the lake on the weekends and in the summer. Sunday outings were the norm in the afternoons after church when young women could go there to gossip and flirt with the boys, who would be showing off with their latest swimming stunt or racing. (Courtesy Bon Air Public Library.)

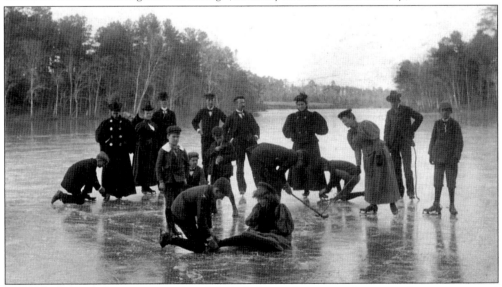

While the summer drew many people to Jahnke Lake, in the winter, there were also many seasonal activities available to the residents. Skating, hunting, and walking trails were abundant. Here some adventurous skaters attempt to maneuver on the icy lake. The lake was located between Fernwood and Shady Echo. The lake was formed when a dam was set up on the creek. Landowners along the lake complained to Mr. Jahnke about the fact that the lake would overflow and flood their land. Finally, in 1914, he was forced to break the dam and empty the lake. (Courtesy Bon Air Public Library.)

The Watermelon Festival, held for many years by Mr. and Mrs. C. B. Graves at their home in Chester, was a popular event. The festival was organized on the Graves lawn and became a tradition with good food and wonderful entertainment. Mr. Graves (left), known as "Benny," and Hugo Mann (right), pictured in 1920, played in a band with Jack Holt, Robert Bell, Paul Pride, Richard Williams, Garland Graves, ? Jones, and Charles Burton. The group performed together in the 1930s as the Tobacco Tags. The festival grew, and by 1937, 600 guests attended the 15th annual event, feasting on watermelon and enjoying the entertainment. Benny Graves was the Chester postmaster for many years. (Courtesy Chesterfield Historical Society of Virginia.)

Horse racing was a popular sport in Chesterfield, and Junious Horner, pictured here, was involved in numerous horse racing endeavors in the 1920s and 1930s. Here is a race at the Chesterfield County Fair during that time period. (Courtesy Chesterfield Historical Society of Virginia.)

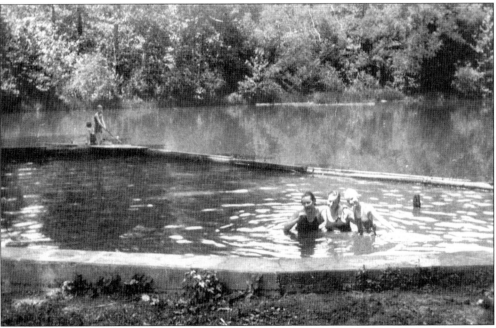

Warm summer afternoons at Pollard's Pond in Bon Air were very inviting to the young people in the area. Shown here in 1930, the three girls in the foreground are, from left to right, unidentified, Nana Mercer Fraker, and Jan Welch. In the background are two younger children fishing. (Courtesy Bon Air Public Library.)

In 1974, Jesse Owens, a gold medalist in the 1936 Olympics and "ambassador of sports" for the United States, spoke to a crowd at Clover High School, including students as well as local athletes and the news media, about his experiences. Clover Hill High School was built on Hull Street near a number of growing subdivisions, offering students in the school district many opportunities to learn and be exposed to interesting people and experiences.

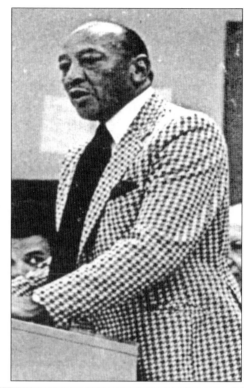

In 1940, the Chester Pharmacy served the community with prescriptions and other sundries. A group of young men frequented the establishment and went by the name "The Drugstore Cowboys." The group included, from left to right, Robert Pearce, Dick Valentine, ? West, Coleman Davis, Billy Huntzman, unidentified, Arthur Lindsey, Sherwood Bass, Willis Fore, Philip Purdue, and Wilton Sanders. The pharmacy was located in Chester at Harrowgate and Bermuda Hundred Roads. (Courtesy Chesterfield Historical Society of Virginia.)

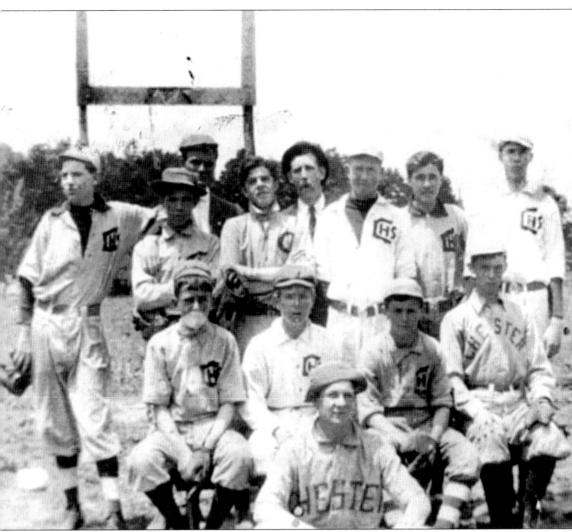

In 1915, Chester was home to a semi-professional baseball team that was part of the Piedmont League. The team was owned by Mr. Burnham of Chester. He was a local building contractor and served as the coach of the team. The team members include Colbert Tyler, Fred Shepherd, Fisher Bruce, Graham Bruce, Ray Zottman, Letwich Bowles, George Shepherd, Hugh Cousins Goodwyn, Ingles Cousins Goodwyn, Mr. Reese (assistant coach), Mr. Burnham (coach and owner), and two unidentified players. (Courtesy Chesterfield Historical Society of Virginia.)

In 1976, there were many celebrations around the county marking the 200th anniversary of American independence. Shown here are some parishioners of the Wood's United Methodist Church dressed in costume for the celebration. From left to right are Mason T. Chalkley, Wayne Beville, Jim Fry, Howard Bickings, Ben Schenck, James Dyson Sr., Jeff Shelton, Rev. Gary Ziegler, and John Dyson. (Courtesy Mary Perkinson Chalkley.)

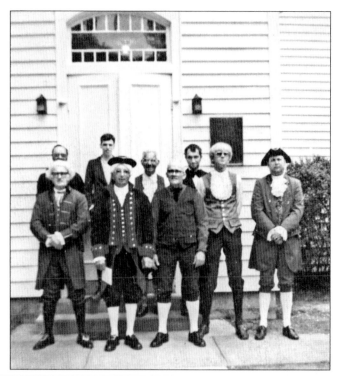

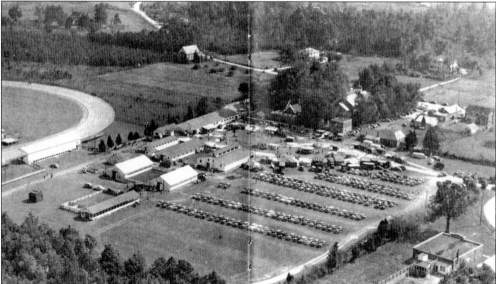

The Chesterfield Fair was a major event, and county residents came to represent their clubs and organizations. The fair began in 1911, when a group of farmers got together to see who had the best corn crop. Until 1950, there were two separate fairs; one for blacks and one for whites. This aerial picture of the Chesterfield County Fair in 1948 shows the fair as it looked when located behind the 1917 courthouse. Pictured in the top left hand corner are Walter Perdue's house and the Trinity Methodist Church. In the top right hand corner is Magnolia Grange. The road is Route 10, and it goes past the old jail and the old circuit court building in the middle of the picture. At bottom left is the harness racing course.(Courtesy Mary Perkinson Chalkley.)

Deer Range Hunting Lodge was a popular place for hunters to gather and talk about the day's events. It was owned by W. T. Chapman. The pictures that adorned the walls showed the different scenes of hunters and their prey. There were also skins on the ceiling and trophies. (Courtesy Chesterfield Historical Society of Virginia.)

BIBLIOGRAPHY

Clafin, Mary Anne and Elizabeth Guy Richardson. *Bon Air*. Richmond: Hale Publishing.

Goodwyn, W. Hugh, Mary Arline McGuire, Lucille Cheatham Moseley, and Jennifer Dawn Wright. *A Time to Remember: A Pictorial History of Chesterfield County, Virginia, 1860–1960*. Chesterfield: Chesterfield Historical Society of Virginia, 1993.

Lutz, Francis Earle. *Chesterfield County: An Old Virginia County, Volume I: 1607–1954*. Richmond: Bermuda Ruritan Club, 1954.

O'Dell, Jeffrey M. *Chesterfield County Early Architecture and Historic Sites*. Richmond: Chesterfield County, 1983.

Silvers, Dorothy Fuller. *Chesterfield: An Old Virginia County, Volume II, 1955–1989*. Richmond: Chesterfield Museum Committee of the Chesterfield Historical Society of Virginia, 1992.

Walker, Jane C. and Second Grade Class Stony Point School. *Discovering Stony Point*. Richmond: Stony Point School, 2002.

Weaver, Bettie Woodson. *Chesterfield County Virginia—A History 1970*. Richmond: Chesterfield County, 1970.

———. *Midlothian—Highlights of Its History*. Midlothian: Sheridan Publishing, 1994.